LATINO HISTORY
in
RHODE ISLAND
· *Nuestras Raíces* ·

MARTA V. MARTÍNEZ

Charleston | London

THE
History
PRESS

Published by The History Press
Charleston, SC 29403
www.historypress.net

Cover image, front: Top left image courtesy of the *Providence Journal*; top right image courtesy of Salvatore Mancini; center image courtesy of Josefina Rosario; bottom left image courtesy of José González. *Back*: Right image courtesy of Salvatore Mancini. All other images courtesy of the author.

First published 2014

Manufactured in the United States

ISBN 978.1.62619.550.9

Library of Congress CIP data applied for.

3 1357 00244 3437

This book is dedicated to Juanita Sánchez, who introduced me to many of the pioneers featured in this book and who in the early 1990s gave me much encouragement by insisting that I must not wait to begin gathering these life stories of Latinos in Rhode Island.

CONTENTS

Foreword, by Albert T. Klyberg 7
Acknowledgements 9
Introduction 11

PART I. PROFILES OF RHODE ISLAND'S
 SPANISH-SPEAKING POPULATION 15

PART II. BACKGROUND 17

From Agriculture and Migrant Work to Building Railroads 19
World War I and World War II: A Labor Shortage Brings
 More Latinos to Rhode Island 20
The 1950s and 1960s: Cuban Migration to the United States 22

PART III. LATINOS IN RHODE ISLAND 25

The Dominicans 26
The Puerto Ricans 30
The Cubans 33
The Colombians 39

Contents

The Guatemalans 44
The Mexicans 48

Part IV. The History of Latino Community Social Activism and Political Growth in Rhode Island 55

Rhode Island's First Latino Social Service Agencies 58
Latino Social Activism Begins to Take Shape 61
Political Advocacy 62

Part V. The Pioneers 67

Josefina "Doña Fefa" Rosario 67
Victor Mendóza 76
Reverend Juán Francísco 82
Valentín Ríos 86
Don Pedro Cano Sr. 92
Olga (Escobar) Noguéra 95
Roberto González, Esq. 97
Osvaldo "Ozzie" Castillo 104
José M. González, EdD 107
Tessie Salabert 112
Miriam (Salabert) Gorriaran 119

Part VI. How You Can Participate in the Latino Oral History Project of Rhode Island 127

Bibliography 131
Index 135
About the Author 143

FOREWORD

Rhode Island has worn out many welcome mats in the nearly four hundred years since the Native American Narragansetts welcomed Roger Williams and his little band of religious refugees at the Slate Rock on the Seekonk River in 1636. About twenty years later, Portuguese Jews and English Quakers, unwelcome in other settlements of New England, arrived in Newport to live their faiths and practice their commerce "where none would be molested or troubled for their conscience sake."

In the decades that followed, indentured servants, African slaves and poor—but proud—groups arrived by their own choice, or by the coercion of others, to chase a living or to await an alleviated status. Befitting an ocean state, in the nineteenth century, other people arrived in waves: English textile spinners and weavers and Irish laborers to build Fort Adams, dig the Blackstone Canal and lay down ties and tracks for the state's railroads. During and after the Civil War, French Canadian farm families left Quebec for jobs in the Rhode Island mills. Italians left famine-strapped southern Italy. Russian Jews fled the pogroms. Mainland Portuguese, Azoreans and Cape Verdeans joined the flood of Mediterranean people from Greece, Syria/Lebanon and Armenia, while northern, western and eastern Europe contributed people from Germany, Sweden, the Baltic countries, Poland and the Ukraine. People came for jobs and a better chance for the future of their families.

The arrival of the Latinos to Rhode Island in the mid-twentieth century followed many of the paths of predecessors—except in one respect. The rise of oral history as a program of documenting, firsthand, the experiences

as well as the expectations of newcomers has refined the immigrant story in major dimensions. No longer do historians have to guess or depend on serendipitous fragments of documentation. A broad sampling of stories is now available in the living testimony of the new arrivals.

The documentation of our Latino population has another welcomed aspect. For earlier immigrants, it sometimes took decades or even a century for them to become full participants in the Rhode Island community. Sometimes it was because of intentional barriers of discrimination. In other cases, it was because of their uncertainty about acceptance. A scarcity of identified role models often caused a reluctance to venture into the public arena of politics and community service. At one time, the looking glass, the mirror of Rhode Island history, was tall and narrow. It did not include the faces of the wider Rhode Island community. Many felt that it was not their place to be involved, to aspire to public office or to voice their opinions about the "customs of neighbors"—the way things were run—not just in city hall but in the parishes, the sports leagues and the hundreds of voluntary organizations that are the fabric of everyday life.

Finally, with the "voices of Rhode Island's Latino pioneers," the widespread accomplishments of our Latino neighbors and leaders are clear and inspirational to the rising generations of citizens, once left out of the mirror of Rhode Island history. Now, today, every day can be "Memorial Day."

ALBERT T. KLYBERG, LHD
Director Emeritus, Rhode Island Historical Society
May 26, 2014

ACKNOWLEDGEMENTS

I would like to express my gratitude to the following individuals, without whose contributions and support this book would not have been written.

Juanita Sánchez, who introduced me to many of the pioneers featured in this book and who never thought of herself as a "pioneer" but was considered an "unsung hero" by many of the pioneers featured in this book.

Josefina "Fefa" Rosario and Jay Giuttari, two important pioneers mentioned in this book, who may not realize what they created when they planted the "seeds" of a small enclave of friends and family. Who would have ever imagined that in 2014, those seeds would become the fastest-growing and most politically powerful ethnic group in Providence, numbering 117,819 residents, or about 19 percent of the 626,667 population. Statewide, Hispanics increased from 90,820, or 8.7 percent of Rhode Islanders, to 130,655, or 12.4 percent.

Mary V. Quintas and José P. Youngs, who provided the technical assistance that made it possible to complete this book.

Michelle DePlante and Winifred Lambrecht, for your assistance in the collection of Cuban stories in the project.

To the families of the pioneers, for your help in obtaining photos and clarifying details of the oral history interviews: Anna Cano-Morales, Lori Giuttari, Suzanne Lewis, Madeline Rosario, Cecilia Rosario and Eduardo Salabert.

To the Rhode Island Council for the Humanities (RICH) and Herman Rose, chair of the ADDD Fund at the Rhode Island Foundation, for

providing funds to complete the Cuban stories of this important oral history collection.

To the (former) International Institute of Rhode Island (IIRI), now Dorcas IIRI, for the use of your valuable archives.

A portion of the royalties will be donated to the Juanita Sánchez Community Fund at the Rhode Island Foundation and also to the Tam Tran Scholarship fund.

The Latino Oral History Project is managed by the Hispanic Heritage Committee of the Rhode Island Latino Arts Inc. Nuestras Raíces is Rhode Island's first oral history project that celebrates the history and tells the stories of our Latino pioneers. For more information, or to participate in the Latino Oral History Project of Rhode Island, write to us at PO Box 25118, Providence, RI, 02905, or send an e-mail to info@nuestrasraicesri.org. You can also visit our website at www.nuestrasraicesri.org.

INTRODUCTION

The Latino Oral History Project of Rhode Island began in 1991 when I met and recorded the memories of Josefina Rosario, who had been co-owner (with her husband, Tony) of Fefa's Market, the first Latino market in Rhode Island. Later, I met with and recorded the voices of many other Latino pioneers, among them factory workers, community activists, social service providers, artists, elected officials, educators and others.

As the project moved forward, I chose to focus on the four Latino groups whom the U.S. Census showed were the largest in Rhode Island at the time: the Dominicans, Puerto Ricans, Colombians and Guatemalans. Twenty years later, the 2010 census showed that these four main groups were still the largest and fastest growing in the state and that the overall numbers are significant compared to the greater population of Rhode Island.

The Spanish word *raíces* means "roots" in English, and this explains what this project is all about. It is about the history of the Latino community of Rhode Island and how it all began. It is about the first Dominican family, the first Colombian millworkers and the first Guatemalan jewelry makers who came to Rhode Island. It is about the first Hispanic physician to open a health clinic on Broad Street, the first Latino students in the public schools and the first Hispanic police officer in the state. The most important observation I discovered through this project, and the one that is hardest to comprehend, is that until the mid-1950s, there was no evidence of significant numbers of Latinos anywhere in the state of Rhode Island!

The life of a long-ago immigrant or a recent arrival to America is a particularly rich topic for exploration through oral history. Granted, it is not easy to trace the personal lives of those who first made their way to America as far back as the turn of the twentieth century, when America first began receiving countless immigrants from Europe. However, as I set out to do this project, I found it relatively easy to find individuals who came to Rhode Island from Spanish-speaking countries mainly because Hispanics began arriving and settling here as recently as the 1940s and '50s. Today, there are still hundreds of Latinos living in Rhode Island with vivid memories of their first arrival to this state during those early years. This project captures the stories of only a few significant individuals, and as we move ahead, we hope to continue collecting as many of those voices as possible. Please keep in mind while reading this book that there are so many stories that still need to be collected and that history is being created every single day.

As the collection of oral histories moves forward, the Latino Oral History Project of Rhode Island will begin expanding its collection from the stories

of the pioneers to include all of the diverse and growing Latino communities in the state. Latinos today are found in urban and rural communities all over the state, contributing enormously to the cultural, social, political and economic fabric of Rhode Island. Within the next decade, Latinos will become Rhode Island's largest minority population, yet only a very few organizations in Rhode Island are actively collecting significant information about Latinos.

Much of the documentation that records the rich history and culture of these diverse communities statewide is in danger of being lost. Historical information is inadequately represented in the documentation of broad areas of Latino culture, including the fine arts, popular music, dance forms and folk and traditional arts. Similarly, information is extremely limited about Hispanic businesses and social, political, community and religious organizations. Latino and Latina experiences with and responses to issues of immigration and migration, discrimination, economic opportunity, public education, healthcare, law enforcement and social services are poorly represented in historical records. Even the substantial contributions of various Latino and Latina community leaders and politicians from Rhode Island at the local, state and even national level are seriously lacking adequate documentation.

Why is this collection of oral histories of Rhode Island's Latino pioneers so important? In his book *Our America: A Hispanic History of the United States*, Felipe Fernández-Armesto makes the argument that if the United States wants to be a great nation in the future, it needs to embrace its history as a Latin American nation. It becomes more important to expand students' understanding of histories and culture in an increasingly global society, especially in the United States where Latinos are the fastest-growing "minority" population.

When students in Rhode Island who are of Latino heritage do not see themselves as part of history, for many their sense of self may become marginalized. Marginalization negatively affects students' connections with school and their success at school. It may contribute to the high dropout rate for Latinos. A more accurate history, where students can identify themselves, would provide some students with a sense of self and purpose.

The Latino Oral History Project hopes that this collection of personal stories by Rhode Island's Latino pioneers can help young people acquire and learn to use the skills, knowledge and attitudes that will prepare them to be competent and responsible citizens throughout their lives. It is our hope that the information in these pages can complement or serve as a supplement

when Rhode Island history is taught in fourth grade and be incorporated later on when students are in middle and high school.

Teachers can visit our website to download supplementary material, including audio files of the Latino voices featured in this book (www.nuestrasraicesri.org). For more details, contact us at PO Box 25118, Providence, RI, 02905 or e-mail at info@nuestrasraicesri.org.

There is still much more to do! If you have a story to share, please contact us. I would be pleased to hear from you! *Si usted desea compartir su historia, póngase en contacto conmigo—¡yo estaría encantada de saber de usted!*

PART I
PROFILES OF RHODE ISLAND'S SPANISH-SPEAKING POPULATION

The 1960s became a time of much movement and growth across the country, brought on by civil rights groups, young people (flower power) and the women's movement. In Rhode Island, it was also a time of growth and prosperity among countless Spanish-speaking immigrants. As you read through this book, you will get a brief historical description of this growth beginning in the late 1950s and leading right through the 1970s and '80s, when the greatest Latino immigration and migration patterns were recorded in the state.

The oral histories found in later pages of this book play an important role in bringing each of the profiled Latino groups to life. They provide us with insight into the minds of the individuals whom we consider to be the *pioneros* (pioneers), those who made history through their dedication and hard work as members of the ever-growing Latino population of Rhode Island.

These people interviewed for this oral history project were among the first Spanish-speaking people to settle in Rhode Island. Many of these men and women were hardworking individuals in their countries. Some of these pioneers left their families and friends, and many knew it would be a long time, if ever, before they saw them again. There were doctors, business owners, architects, lawyers, teachers and many others. They paved the way for the rest of us, and without their foresight and fortitude, today's Rhode Island Latinos may not be the largest and fastest-growing successful community in the state.

PART II
BACKGROUND

In very large measure, immigration to Rhode Island by Latinos (including migration by the Puerto Rican population) occurred in the late 1960s and early 1970s. However, earlier records of a Hispanic presence in Rhode Island can be traced as far back as 1834. For example, records found in customs passenger lists and customhouse records list a family of six—ranging from ages one to thirty-five—who reportedly arrived in the Port of Providence after having boarded a ship that left from Matánzas, Cuba. Further, records of activists in the struggle for independence of Cuba and Puerto Rico from Spain show that in 1892, José Martí, known as the leader of the Cuban *libertadores* (freedom fighters), in an article in the Cuban newspaper *Patria* mentions a visit to the independence club *Cuba-Borrinquen* in Boston during his second exile from Cuba. Later in the article, he writes about a quick trip south to meet with another such group in "a neighboring state," leaving one with a sense that there were Cubans and Puerto Ricans living in this area more than one hundred years ago.

After this account, there is little known about the Latino community's presence in Rhode Island until the mid-1950s, although there is some evidence to suggest that there were small pockets of Spanish-speaking immigrants living in Rhode Island before this period. For example, the headline of a 1938 article in the *Providence Journal* states that there were "not more than 15 Mexicans in Rhode Island." The story goes on to say that "brisk business with that country" warranted the appointment of Edgar L. Burchell as Mexican consul in Rhode Island. Having been appointed

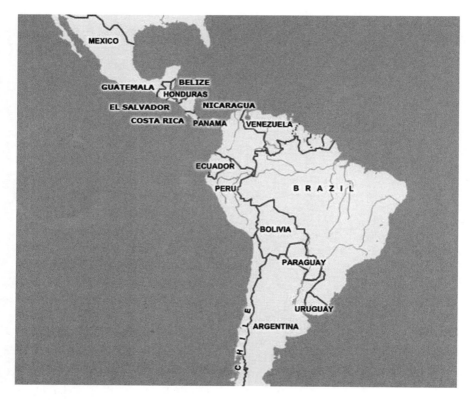

Map of South and Central America. *Courtesy http://www.cochera-andina.com/es/inicio.*

in 1924, Burchell set up an office at 42 Westminster Street in Providence, where he also served as "immigration officer, diplomat, tourist agent and tax collector." According to the article, this was the first Mexican consul in Rhode Island (the only other such office in New England was then and still is located in Boston). By the mid-1930s, no records were found that a Mexican Consulate Office still existed in Providence, so it is assumed that Mr. Burchell and the U.S. government no longer felt the need to keep it open. Research shows that to date, that has been the only Mexican consul in the state.

The International Institute of Rhode Island was founded in 1921 with the mission of providing social services to Rhode Island's fast-growing immigrant population. The archives of this organization record the existence of a number of Latin American social clubs, events and a list of Spanish-speaking individuals who sought services at the agency during the first part of the twentieth century. For example, these archives reveal the existence of

El Club Panamericano, a social club whose members (all of whom were women) represented various countries in the Americas. According to a *Providence Journal* article dated November 8, 1941, this club was headed by Cecilia Rodríguez, a native of Argentina. Similarly, the archives of the Providence Catholic Diocese also show that Hispanics not only formed a number of Church-run social clubs but also received services through the Catholic Church, such as English-language training and settlement assistance. The diocese went further by opening the first Hispanic social service agency in the city of Providence in the 1970s. The agency had a Latino director, and the offices were set up in the Olneyville section of Providence.

FROM AGRICULTURE AND MIGRANT WORK TO BUILDING RAILROADS

The Mexican immigration to the United States between 1890 and 1965 has been called one of the most significant demographic phenomena in the history of the Americas. This Mexican migration took many forms and contributed greatly to the growth and development of the United States as a nation. The first movement to *El Norte* (the north) took place after the 1910 revolution in Mexico, when farmhands, shepherds, miners and cowboys felt a call to go north in search of better and higher-paying work. Men and women who were unable to find decent work within their borders moved northward to find a job. They left Mexico looking for a land of milk and honey, where they could raise their children properly and prosperously.

Mexicans began relocating first to the Southwest United States to find employment, taking advantage of their agricultural traditions wherever they could. With the expansion of the railroads in the early 1920s, Mexicans went to work as track maintenance workers. Between the 1920s and 1940s, a large migration began to take place from the Southwest to industrial cities all across America. Mexicans not only began to find employment in steel factories in the Midwest, but they also found jobs with companies farther north, such as the Baltimore and Ohio Railroad Company and in Pennsylvania. As the railroad work expanded to the northeastern states, a *Providence Journal-Bulletin* article in 1944 indicated that Rhode Island got its share of Mexicans to work on the New Haven Railroad and settled sixty Mexican workers at a labor

camp in East Greenwich "to help meet a labor shortage suffered by the railroad in this area."

As for the Mexican Consulate of the 1930s, it is very likely that the Mexicans whom Mr. Burchell and his consulate office were serving came to Rhode Island onboard cargo ships during the rise of steel trade between the United States and southern and midwestern states where the Mexicans had settled. At that time, the Port of Providence served as a drop-off point to other northern states and Canada, and the Mexicans onboard these ships were most likely ship hands who needed a place to stay while the ship sat docked for days, weeks and sometimes long months in Providence. Records show that some of these individuals traveled to Connecticut to work in tobacco and sugar cane fields while they waited for the ship to return to Mexico.

Also during that time, there was an abundance of jobs in meatpacking plants, utility companies, construction, trucking and eventually in agricultural trades, such as sugar beet fields in Michigan and tobacco, vegetable and fruit fields in New England. These jobs were the kind that did not require special skills or the ability to speak English. Rhode Island had its share of agricultural farms during this time, and with it came a need for cheap labor and dedication. The Mexican workers and other non-English-speaking immigrants, who were available to provide this labor, were hired to do this work.

WORLD WAR I AND WORLD WAR II: A LABOR SHORTAGE BRINGS MORE LATINOS TO RHODE ISLAND

During World Wars I and II, many Mexican Americans and Puerto Ricans were drafted for the first time to fight in the war on a large scale. Many of them also volunteered to fight overseas. While the Puerto Ricans had been coming to the United States mainland since the early 1900s, when the island became a U.S. protectorate, the real migration occurred after World War II. For both Mexicans and Puerto Ricans, serving in the war was the benchmark for self-awareness. This was due in part to the fact that many had left crowded, unsanitary *barrios* for the first time and were suddenly exposed to new ideas of fairness and equality. These Latinos not only learned new skills that they could not have developed in their rural communities, but for the Puerto Ricans, it was also a grand exposure to mainland prosperity.

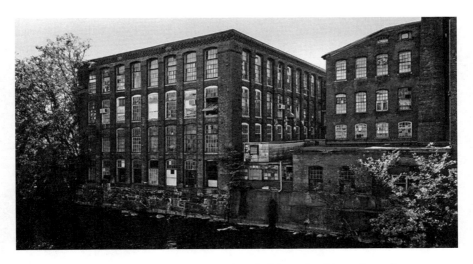

Textile mill building in Central Falls, Rhode Island. *Courtesy* Providence Journal.

In the 1930s, leading up to World War II, the United States found itself with a great labor shortage because Americans were going off to fight in Europe. During that time, the government lifted any immigration laws and allowed Mexican workers through the borders. In the 1920s and '30s, cotton growers in southern states imported thousands of these workers to work in the fields, an industry that had a great need for cheap labor.

Beginning in 1942, temporary workers were brought from Puerto Rico and Mexico through the *bracero* program, which was a labor agreement between the United States and Mexico. Although the program brought Mexicans to the United States to work primarily in agriculture, some workers were also employed in various industries. More than 100,000 contracts were signed between 1943 and 1945 to recruit and transport Mexican workers to cities all around the United States for employment on the railroads. Rhode Island was no exception when, in 1944, up to 142 men were brought to East Greenwich to work on the New Haven Railroad.

Until the introduction of synthetic fibers, almost all clothing was made from cotton or wool. After the cotton was picked by Mexican laborers in southern states such as Georgia, Alabama and North and South Carolina, it was first sent to cotton gins for processing and then it came to New England lacework factories and textile mills, where it was woven into fabrics. This process of importing cotton from the South continued for the next several decades—well into the 1980s.

In Rhode Island, textile mills in Central Falls such as Lyon Fabrics, Pontiac and Cadillac benefited greatly from the heavy importation of cotton, and while jobs were in abundance at the time, there were not enough skilled workers to keep up with the amount of work that needed to be done. It was that need that started the active recruitment of individuals from Colombia, an act that contributed greatly to the birth and growth of the Colombian community in the Rhode Island.

THE 1950S AND 1960S: CUBAN MIGRATION TO THE UNITED STATES

Cuban immigration to the United States began in the Spanish colonial period. When Pedro Menéndez de Avilés established St. Augustine, Florida, in 1565, hundreds of Spanish-Cuban soldiers moved to the city. During the Ten Years' War (1868–78) between Cuban nationals and the Spanish military, Cuban cigar manufacturers moved their operations—along with hundreds of workers—to Florida to escape unrest. From 1900 to 1959, an estimated 100,000 Cubans immigrated to the United States, including those looking for work during the Great Depression and anti-Batista refugees, as well as supporters of the ousted Batista government in 1959.

After Fidel Castro's Cuban Revolution, hundreds of thousands of Cubans immigrated to the United States from 1960 to 1979. Sparked by rumors that the Cuban government planned to place children in military schools and Soviet labor camps, *Operación Pedro Pan* brought more than fourteen thousand children to Miami between 1960 and 1962. With the assistance of the Roman Catholic Archdiocese of Miami, boys and girls as young as eight years and as old as sixteen years were placed in foster homes and group homes throughout the United States, and it was expected that their parents would quickly leave Cuba to be reunited with their children.

In Rhode Island, the greatest Cuban exodus took place between 1959 and 1963, when young children were received and placed in foster homes in Providence, Pawtucket and Bristol. Hospitals such as Memorial in Pawtucket and Miriam in the East Side of Providence hired a number of Cuban physicians and medical professionals, and the Cuban Club of Rhode Island was formed to welcome Cuban families who came to the United States as refugees of the Castro regime.

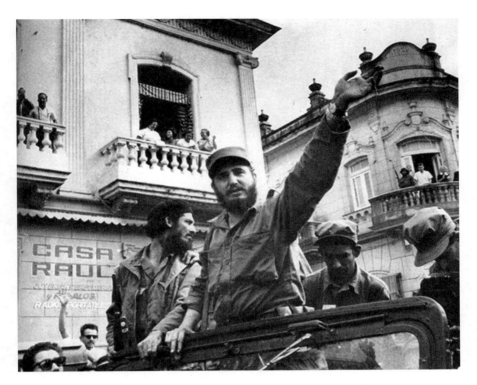

Fidel Castro waves to supporters after he takes over Cuba in 1959. *Courtesy Library of Congress.*

In 1980, housing and job shortages led about 10,000 Cubans to apply for asylum at the Peruvian embassy on the island. Due to the sheer number of Cubans seeking asylum, Castro permitted anyone wishing to leave to do so through the Port of Mariel. An estimated 125,000 refugees fled to the United States during the Mariel Boatlift.

While the southeastern part of the United States was experiencing a large exodus of Cubans in the 1980s, Rhode Island's Cuban community began to decrease as many of the original families who came looking to be reunited with their children moved away to be with them in other parts of the country. By 1986, the Cuban Club of Rhode Island no longer existed, and organizations like the International Institute of Rhode Island and the Rhode Island Office of Immigration and Naturalization Service (INS) reported that only twenty-eight Cubans had responded to notices sent out for them to apply for their permanent residency.

PART III
LATINOS IN RHODE ISLAND

S ince the turn of the century, the United States has been experiencing a major wave of immigration, and as it was in the nineteenth century, twentieth century and the early part of this one, the state of Rhode Island has been and still is a major destination for immigrant settlement.

In recent history, immigrants have been arriving to the Ocean State from such countries as Cambodia, Ghana and Vietnam, as well as Eastern Bloc countries such as East Germany and Russia. Since the 1950s, these have included every Spanish-speaking country in the world. According to the 2010 census, the total Hispanic population in Rhode Island was 120,586 (that's an increase overall of 11.4 percent since 2000), and the four largest Hispanic ethnic groups are Dominicans (33,879), Puerto Ricans (29,904), Guatemalans (18,125) and Colombians (9,998).

These numbers now prove that Latinos are not only one of the fastest-growing groups in Rhode Island, but also that they carry a great amount of political power in the state. The population of Central Falls alone saw a rise of 9 percent from the last census, with a 48 percent Latino count in that city.

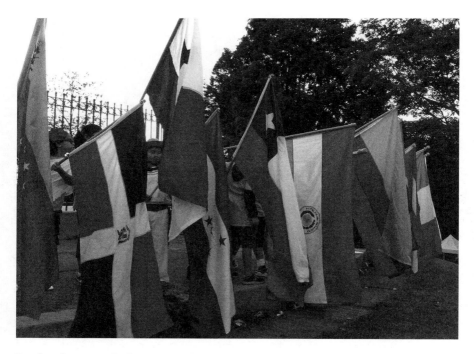

Local students wave Latin American flags during celebration of Hispanic Heritage Month 2013, at the Bright Future Festival in Central Falls, Rhode Island. *Photo by Marta V. Martínez.*

THE DOMINICANS

As it has been with Cuba and Puerto Rico, the United States has always maintained a strong strategic geopolitical and economic interest in the Dominican Republic. By the late nineteenth century, the United States was involved in covert plans to annex the island, and following a period in which it controlled the collection and application of Dominican customs revenue, it occupied the island from 1916 to 1924. At their departure, the military forces left in power General Rafael Leónides Trujillo, a dictator who would go on to rule the island for thirty years of the most brutal tyranny in the Caribbean.

In 1963, two years after the fall of Trujillo, more than 10,000 Dominicans began to enter into the United States, whereas two years before this figure was a mere 3,045. By 1966, when the United States was removing its forces from the island, more than 16,500 Dominicans were entering the United States every year.

There are several factors that caused Dominican immigration to the United States during earlier waves. In the 1970s and '80s, the biggest reason for Dominican immigration was

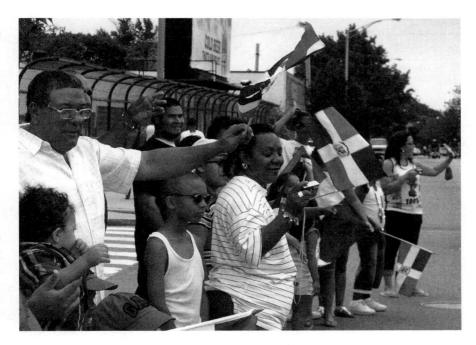

Dominican Festival, Providence, Rhode Island. *Photo by Marta V. Martínez.*

family reunification. Facilitated by the Family Reunification Act of the Immigration and Naturalization Act, many Dominicans came to the United States under the sponsorship of spouses, parents or siblings. They were thus welcomed into the United States by an already-established Dominican community—one that facilitated their entrance into the economic and social aspects of American society.

Although most literature today will chart the immigration patterns of Dominicans from the Dominican Republic to New York City, a sizable population of Dominicans can also be found in the city of Providence. The story of the Dominicans in Providence, however, is one of migration, not immigration. Between 1980 and 1990, the Hispanic population of Rhode Island grew by 132 percent and during the next decade by 98.5 percent. Although many Dominicans have made their home in New York since the passage of the Family Reunification Act of 1965, their arrival to Rhode Island took place almost a decade later.

Beginning in the 1970s and running through the 1990s, Providence experienced a steady increase in its Hispanic population, mainly people

looking for a way to get out of New York City. The migration of Dominicans and other Hispanics toward the New England states occurred for a variety of reasons. Like most immigrants, the Dominicans came to the United States looking for a better life. Their trip northward stemmed from the same reasoning. Since New York City is the first stop for many Dominicans, the overcrowding of the city and the heavy concentration of Latinos there were cited as one of the main factors for leaving. Described by many Dominicans as beautiful due to its small-town infrastructures, some of them moved to Providence to escape the city atmosphere and the tight ethnic enclaves. Dominicans currently living in Providence say that Rhode Island especially offered a safe environment for Dominicans with children.

Employment was another motivation for the migration from New York City to Providence. New factories started opening up in New England, and jobs became available to the Dominicans, mainly in jewelry and textile mills. During that time, it was said that jobs were so abundant that factory owners took to the streets to look for workers. And Dominicans who found these jobs sent home word of the employment opportunities with money tucked inside their letters.

To many Dominicans, Providence was and still is the city of choice because this is where many of the first Latinos settled and continue to reside today. During the late 1950s and 1960s, there were not many Latinos in Providence, and certainly fewer in other parts of Rhode Island, to help them acclimate to their new home. Without family, many Hispanics relied on the help of a woman named Josefina Rosario (fondly known as "Doña Fefa"), as well as her family. Many people came to visit her in Providence before moving here and stayed with Doña Fefa. To many, she was their only friend and ally. For years, Fefa and her husband, Tony, cordoned off sections of their apartment located on Chester Street, off Broad Street in the Southside of Providence, and housed the newcomers. They helped their guests find jobs in restaurants, jewelry factories and textile mills. They went as far as to go with them to help them get a driver's license and Social Security card, and they even provided assistance with enrolling their children into the public schools.

The Rosarios were not only the first Latino couple to arrive in Rhode Island from New York City in 1952 but were also the first to open a Hispanic food market in the state, called Fefa's Market. Today, the Dominican community is clearly the leader in Hispanic-owned businesses on Broad Street, Elmwood Avenue and Cranston Street in the city of Providence. Providence is now a community that has been shaped by Latinos, their experiences and their customs. A walk along Broad Street and other

Mayor Angel Taveras. *Courtesy Salvatore Mancini.*

neighborhoods in the Southside, West End and Olneyville of Providence boasts the entrepreneurial endeavors of Dominicans in the form of bodegas, restaurants and beauty salons, along with the many cultural symbols of success. Today's Dominicans also boast the highest political activity among Latinos in Rhode Island. As of this publication, this community has helped elect four Dominicans to the Providence City Council, two Latinas and one Latino legislators to House seats and the first Latino senator to serve in the Rhode Island State House.

Of course, we cannot forget to mention that in 2010, Providence residents elected the first Hispanic mayor of that city and the third-elected and fourth-serving Dominican American mayor in the United States, a man who in 2014 officially announced his bid for the gubernatorial election.

THE PUERTO RICANS

Puerto Ricans are the second-largest Spanish-speaking group in the United States. They are American citizens by birth. Their movement to and from Puerto Rico is considered part of the internal migration of Americans and not "immigration" per se, as is the case for Mexicans, Cubans, Colombians and all other Hispanic peoples. The first major wave of migration to the mainland did not begin until the early 1900s. Puerto Ricans were brought to the United States to fill a need for farmworkers, and many of the migrants went directly to Arizona, Texas and California. A larger number went to the Northeast to states like Connecticut to work in agricultural farms, harvesting tobacco and sugar cane.

The first Puerto Ricans who came to Providence did so in the 1920s. They moved to Providence and the surrounding areas to find work in the agriculture and manufacturing industries. Estimates of how many Hispanic people were living in Rhode Island before this time are complicated by the lack of information found in federal census records, which at the time were not broken down by ethnic group.

One historian in Rhode Island has suggested that the first evidence of increasing Puerto Rican migration in Rhode Island occurred in the late 1950s. However, our oral history project reveals that Puerto Ricans began emigrating from that island to Rhode Island in the 1920s, when dozens of Puerto Rican migrant workers were brought here to work on farms located in the Elmwood neighborhood of Providence. One such individual was Julio

Puerto Rican parade, Providence, Rhode Island. *Courtesy Salvatore Mancini.*

Casiano, who at the age of twenty-two came to Rhode Island in the spring of 1926. According to Casiano, he and a group of men were brought here by Jewish landowners to help out in farms every spring and were then allowed to return to Puerto Rico in November, after the harvest was completed and just before the cold weather arrived. At the time, Casiano and the other Puerto Rican workers felt that economic opportunities were greater here than in their homeland. However, despite the opportunities offered to them, Casiano said that the majority of the men would return to Puerto Rico because they were not accustomed to the cold weather. During that same period, many Puerto Ricans also found their way to Newport, Bristol and places in South County to work in nurseries.

Most of today's Puerto Ricans came to Rhode Island by way of New York, migrating here between 1945 and 1970. Many of them were impoverished, unemployed or underemployed and came from rural and urban areas of the island. Most came with minimal educations. Lacking skills and training, the Puerto Ricans found work in the garment industry, restaurants or other service jobs in New York City. Work in the manufacturing industry was readily available to the Puerto Rican migrants because it required little or no English skills.

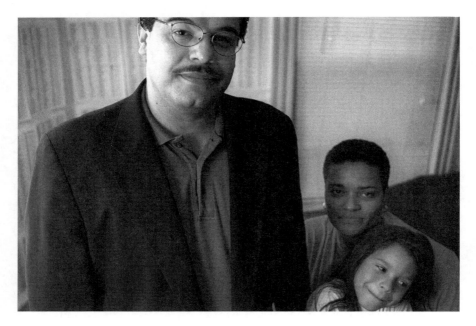

Councilman Luis Aponte, with his wife, Gwen, and daughter. *Courtesy the* Providence Journal.

Puerto Rican workers and their families settled in some of New York's overcrowded and crime-ridden neighborhoods, such as East Harlem and the Bronx. When they ventured beyond New York's borders, they found the living conditions in cities like Providence to be far superior to those in New York, especially if they were raising children. One Puerto Rican business owner on Broad Street in the Southside of Providence who had lived in the Bronx in the 1970s remembers the time he visited his niece in Rhode Island. His wife had recently given birth, and when they saw how quiet and safe it was in Providence compared to their lives in New York, the couple decided to move here.

Stronger evidence shows that the peak of Puerto Rican migration to this area took place in the 1980s. Our project discovered that many of the Puerto Ricans who migrated to Providence before the 1980s did not find many other Puerto Ricans here. Adjusting to this change was often difficult for people who had just come from either Puerto Rico or, more likely, from New York because most had previously been surrounded by large numbers of other Puerto Ricans, with whom they shared language, culture, food and music. Many took for granted the fact that their culture was the norm.

Moving to Providence was a rude awakening for many Puerto Ricans, who also experienced some culture shock. The González brothers (Roberto and José), who were both interviewed for this project, expressed a sense of culture shock after moving from New York City to tiny Rhode Island in 1968, where they found themselves to be two of only six "brown-skinned" students at Central High School in Providence.

Also, until the 1970s, it was hard to find Latin American food, music and other cultural necessities in Rhode Island, and those who did not speak English had an especially hard time because very few state and social service agencies employed bilingual workers. Something as essential as getting one's driver's license became an impossible task for a person who spoke very little or no English.

The fact that there is no hard evidence of Puerto Ricans' settlement in Providence prior to the 1950s and '60s does not necessarily mean that there was no other Hispanic presence in the state before that time. Indeed there was. But as with many other immigrants, it took a decade and a half to begin showing the Latin presence among society. Today, Puerto Ricans are indeed making strong headway into the empowerment of Latinos in Rhode Island. Milestones for this community include the first Hispanic Housing Court judge, the first Latino elected official to the Providence City Council, a prominent physician and activist and two founders of children's educational advocacy groups in the Providence school system in the 1970s and '80s.

THE CUBANS

Cuban immigration to the United States began in the Spanish colonial period. When Pedro Menéndez de Avilés established St. Augustine, Florida, in 1565, hundreds of Spanish-Cuban soldiers moved to the city. During the Ten Years' War (1868–78) between Cuban nationals and the Spanish military, Cuban cigar manufacturers moved their operations—along with hundreds of workers—to Florida to escape unrest. From 1900 to 1959, an estimated 100,000 Cubans immigrated to the United States, including those looking for work during the Great Depression and anti-Batista refugees, as well as supporters of the ousted Batista government in 1959.

Operación Pedro Pan

In 1960, rumors spread throughout Cuba that Fidel Castro was planning to take children from their parents and put them in military schools or send them to the Soviet Union for communist indoctrination. In response to the perceived threat, the United States began Operation Peter Pan (*Operación Pedro Pan*). The Central Intelligence Agency (CIA) ran the program between 1960 and 1962. The idea was to fly children of parents who were opposed to Castro's government to the United States and place them in homes, where they were to wait to be reunited with their families.

According to magazine article written by Cuban author Juán Carlos Rodríguez, this historical event was referred to as Operation Peter Pan because of the Disney movie in which Peter Pan had taken the three Darling children away to Neverland. Rodrígez goes on to say that the name of this operation was sadly ironic because for many of those children who were sent out of Cuba, the United States would be a land from which they would never return home.

When the children arrived in Miami, they were met by Father Bryan O. Walsh, director of Catholic Welfare Bureau, who made sure they were safe and received housing and food. Eventually, as the number of Cuban children grew week by week, the leading issue for the Catholic Welfare Bureau was the lack of facilities to care for the minors in Miami. This was solved by asking Catholic Charities agencies around the country to seek out foster homes for the young exiles. By the time the program had ended, about fourteen thousand children had been transported to Miami and then placed with friends, relatives, foster homes and group homes in about thirty-five states.

In 1962, Reverend Edward J. McGovern, chairman of the Diocesan Bureau of Social Services, was asked by Father Walsh and the Miami Catholic Welfare Bureau to help place families in Rhode Island. Beginning early that year, thirty Cuban children were brought to Rhode Island through the Catholic Charities Bureau of Rhode Island and the St. Vincent de Paul Society.

When they first arrived, many of the children were first placed in temporary homes in Bristol while more permanent homes were found for them. According to local records, Laurence O. Paquette, president of the Central Council, St. Vincent de Paul, rallied sixteen Catholic parishes around Rhode Island to host some of the Cubans, including St. Paul's Church in Cranston; St. Peter's in Warwick, St. John's and St. Teresa in Providence; and others.

The stories of some of these children were featured in the pages of the *Providence Journal* or *Evening Bulletin*, including the following:

- Modesta "Cookie" Valdivia was twelve years old in 1962 when she went from Miami to Denver, Colorado, and then to a foster home in Bristol for a few months. Eventually, she went to live in a home on Williams Street in Providence before she was reunited with her mother and eleven-year-old sister, María, in May 1966. By then, Modesta was sixteen years old. The three of them quickly moved into an apartment on Orms Street in Providence.

- Carlos Hernández was nine years old when he moved to Bristol in March 1962. He attended St. Elizabeth's School. Blanca Rosa Maria de la Concepción, a twenty-six-year-old former teacher from Sancti Spiritus, Cuba, who was working as a housekeeper in Lincoln, Rhode Island, was called in to meet and comfort Carlos. The story noted that Carlos was very homesick because he had left a sister behind in Miami, and his parents were still in Cuba—his father was a "political prisoner" and his mother was "critically ill."

- In April 1962, several girls were placed at the St. Aloysius Home in Smithfield, Rhode Island: sisters Maria Cristina and Maria Elena, sisters Clara and Nancy and sisters Vivien and Ileana. No boys were taken because St. Aloysius did not have room for boys. All the parents of these girls were still in Cuba. According to the newspaper, the girls' last names were not printed in the paper because organizers all felt "nervous about backlash to the families of these Cuban children back in Cuba."

By October 1962, records show that "an additional 190 Cubans" were brought to Rhode Island since the first groups began to arrive

Freedom Flights

Commercial flights between the United States and Cuba ceased with the Cuban Missile Crisis of October 1962. This began a three-year period during which travel between the two countries went through third countries, Spain and Mexico. Ocurring twice a day, Freedom Flights began on December 1,

1965, under an agreement between the two governments for the purpose of family reunion. Parents of unaccompanied minors were accorded first priority. Close to 90 percent of those still in care had been reunited with their parents by June 1966.

Accordingly, the Cubans arriving in Rhode Island were no longer the young people such as those previously mentioned. Instead, the Cubans who arrived were the parents of the children who had been put on planes bound for Miami. These adults were brought to Rhode Island by the Catholic Charities and also placed in temporary homes while they waited to be reunited with their children who lived in other states. Others were given "refugee" status and brought to Rhode Island because they already had family members living in Rhode Island who sponsored and opened their homes to them.

Still others were professionals who had settled in Rhode Island because jobs were made available to them. According to a newspaper article in 1966, most Cubans who came to Rhode Island between 1964 and 1966 were "highly educated professionals; businessmen, medical doctors. Very few were unskilled laborers or blue collar workers."

Most of the Cuban doctors who came to Rhode Island were encouraged to come here by Dr. Blas Moreno, and they found jobs at St. Joseph's Hospital (run by the Catholic Diocese of Providence) and also at Miriam Hospital (run by the Jewish community of Rhode Island). Several were also hired to work at Pawtucket Memorial, including Dr. Eduardo Salabert, who became president of the Cuban Club of Rhode Island.

The Cuban Club of Rhode Island

A 1964 article in the *Providence Visitor* noted that there were 100 Cubans in Rhode Island in 1964, all of whom were settled by the St. Vincent DePaul Society. The article featured Luis and Blanca Fernández, who had just arrived in the fall of 1964, becoming the 99th and 100th Cuban, respectively, in Rhode Island.

By 1967, another article in the *Providence Journal* noted that "there were close to 300 Cubans living in Rhode Island—all refugees from the Castro regime." Some came to Rhode Island from Cuba aboard the Freedom Flights, sponsored by the U.S. State Department. Others escaped aboard fishing boats and skiffs and traveled dangerous waters to reach freedom in the United States. To help the refugees who came to Rhode Island, a

Cuban Club (*El Club Cubano*) was established. It was founded in June 1967 by Cubans who had escaped from their homeland in the late 1950s, during the Batista regime. All of the new arrivals had chosen to live in Rhode Island for various reasons, ranging from job opportunities to friends calling them here, and some were waiting to be reunited with family members.

According to archives of the International Institute of Rhode Island (IIRI), the purpose of *El Club Cubano* was to assist fellow Cubans, primarily by creating a revolving fund to help the new arrivals begin afresh. Like the story of Doña Fefa, and almost about the same time she was settling Dominicans and Puerto Ricans in Rhode Island, the Cubans banded together to help new arrivals find jobs and apartments, providing them with furniture and clothing and giving them moral support. Most important to the newcomers who did not speak English was providing translation and interpretation, as well as introducing them to other Cubans in the community.

Felipe Eiras and his wife were among the first group of Cubans to leave after Castro seized control. Both were architects, and in 1959, they were working at the top level of the Cuban government designing buildings for what they referred to as "one of Castro's pet projects." Before the couple left Cuba in 1960, the Eirases were working on the design for a building that would hold up to twenty-five thousand children. According to Felipe Eiras, "local 'peasants' were used for their labor to get the buildings up." The building was to be where children would live after parents were convinced by Castro's people that they were needed to help Cuba become strong again following Batista's reign. Once the couple realized what they were working on, they decided they had to leave Cuba and found a way to do so.

The couple first lived in New York and then moved to Rhode Island in 1964. The Eirases formed their own company of architectural consultants, and with the leadership of Dr. Eduardo Salabert and his wife, Virginia, they founded *El Club Cubano*. Officers of the club included Dr. Eduardo Salabert, president; Ismael Torres, vice-president; Dr. Alfredo Incera, secretary; and Mr. Felipe Eiras, treasurer. Mrs. Gladys Rivera was elected to head the house committee.

Taking a Census

According to Raymond E. O'Dowd, executive director of the IIRI in 1964, there was an organization prior to *El Club Cubano* called the Cuban Advisory Committee (CAC), and it was formed with the help of the International

Institute of Rhode Island in 1962, when there were fewer than one hundred Cubans living in the state. From 1962 to 1964, the CAC was the official clearinghouse for all Cuban refugees in the state, putting together a "roster" or a census of Cubans, much like the early custom records taken at ports of arrival around the country. Every time a Cuban individual or family arrived in Rhode Island, the IIRI would put them in touch with the CAC, and data was collected mainly so Cubans would be able to make the necessary connections as long as they lived in Rhode Island.

The local Cuban community became a tight group because everyone equally disapproved of Fidel Castro and how he had changed their home country; each had a similar story of how he or she came to the United States. The members of the Cuban community in the 1960s were adamant about focusing on the positive things about their lives in the United States, yet they were determined never to forget their previous lives in Cuba.

Tessie Salabert, daughter of Dr. Salabert, who was interviewed by the Latino Oral History Project of Rhode Island, remembers the closeness of the Cubans in the early days:

> *One of the things I remember most about my childhood and the Cubans here is that we would celebrate events together; family was a big thing. So being in the Cuban Club was always a family affair when we would celebrate events, like holidays that we would have been celebrating in Cuba: Cuban Independence Day or Columbus Day, which was a big deal. It was all these different holidays that would help us keep our Cuban traditions alive. I felt that the Cuban Club was a place for people to join and just spend time together, as one big family, because we felt we didn't all have our families here, so we became each other's family.*

By 1967, the number of Cubans fluctuated around three hundred, as Cuban families came and left to Rhode Island for various reasons: many left for warmer weather, others found work elsewhere and still others had family calling for them who were in other parts of the United States.

The 1980s and the Mariel Boat Lift

In 1980, records show that Rhode Island had registered 300 "Mariel Cubans," but by 1986, only 104 showed up to register at the International Institute of Rhode Island under the Mariel Cuban Adjustment Program

so they could get permanent status in the United States. An officer at the local Immigration and Naturalization Service (INS) surmised that most had probably moved south, to warmer weather or to live with family members elsewhere in the United States who had petitioned for them so they could become U.S. citizens or permanent residents.

By November 1986, the riots by Cubans held in detention centers around the country made national news, and Rhode Island Cubans, such as Alfredo C. Incera, gave their reaction. The riots were caused by an agreement between Fidel Castro and the U.S. government that would reopen relationship between the two countries but that would also send the prisoners at the detention center back to Cuba. Incera pointed out that life in Cuba was so bad that even the prisoners did not want to go back.

A newspaper article noted that "Rhode Island's Cuban community is very small—some estimate its size as only 100 or so."

THE COLOMBIANS

Like most Hispanic immigrants, Colombians coming to the United States did not start to appear in significant numbers until recent decades. In 1960, fewer than three thousand Colombians immigrated to the United States, but by 1965, that number had grown to eleven thousand. Another sixty-five thousand came during the late 1960s, followed by the peak years of Colombian immigration in the 1970s, when up to seventy-eight thousand made their way to the United States. In the 1980s, this wave started to taper off, and today, a slow but steady stream of immigrant peoples still move from Colombia to the United States.

While Colombian immigration today may be caused by the recent years of political turmoil and social unrest, the majority of Colombian immigrants came to the United States before the so-called drug wars. Colombians have a deeply rooted perception about economic and political opportunities in the United States, and this is found to be an important factor for immigration here, more so than war or unemployment back home. Colombians have immigrated to traditional Hispanic destinations such as New York City, Florida and New Jersey but also to peripheral areas such as Rhode Island and Massachusetts.

In this study of the Colombian community of Rhode Island, the city of Central Falls plays a very important role. For it is here that active recruitment of labor by local factories was influential in bringing the large Colombian

Photo by Marta V. Martínez.

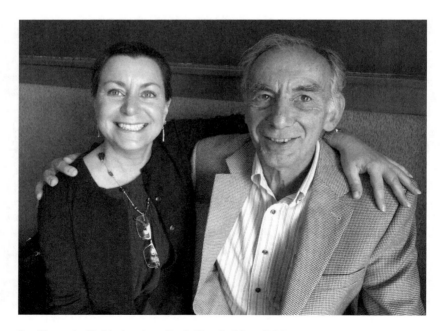

Jay Giutarri with his daughter, Lori. *Photo by Marta V. Martínez.*

population to the state. The Latino Oral History Project of Rhode Island discovered that immigration to Rhode Island by Colombians began in 1965, and the history of Colombians in Rhode Island is connected to some of the factories and textile mills in Central Falls.

Central Falls is located in the Blackstone Valley, north of the city of Providence. It is an area often recognized as the birthplace of the American Revolution, where textiles and factories began to spring up in the 1700s. The first person to bring industry to the region was Samuel Slater, who in 1790 opened the first American cotton-spinning mill in nearby Pawtucket. It was because of Salter's innovative thinking that countless future immigrants to this country found themselves quickly settling into life as millworkers in the Blackstone Valley.

Remarkably enough, almost all of the Colombians who live in Central Falls today come from one of two regions in Colombia: the Antioquia Province, in the central mountainous region, and Barranquilla, located on the Atlantic coast. Antioquia, along with Medellín, its capital, has historically been one of the most developed and industrialized areas of Colombia. As far back as the 1920s, textiles were the biggest manufacturing industry there, besides coffee processing.

The Colombian population in Rhode Island owes its beginnings to one gentleman, who, in the early 1960s, much like Samuel Slater in the 1700s, had an insightful idea. Jay Giuttari, whose father owned Lyon Fabrics Company, a textile mill in Central Falls, was aware that his father, like other mill owners at that time, were having a hard time attracting young people to work in textiles. At the turn of the century, there were many textile mills and an abundance of workers in the textile business in Rhode Island, but by the early 1960s, that was changing. Many of the workers at the mills in Central Falls were aging into their sixties and seventies, and it was rare to see a twenty-year-old weaver. Weaving and loom fixing and working in the textile mill were very difficult jobs, and young people preferred jobs that were not so physically demanding.

In the early 1960s, Giuttari was living and working in Barranquilla, Colombia, and it was there that he saw firsthand the highly skilled work of the textile workers. Because he understood his father's predicament and because he understood textiles, he knew where to find weavers and loom fixers in Colombia. He visited one of the mills across from his job site in Barranquilla and recruited three men to work in his father's mill back in Central Falls. The three men were Valentín Ríos and Gustavo Carreño, both in their twenties, and factory supervisor Horacio Gil, who was fifty

years old. All three arrived in Rhode Island in March 1965. Because these men were already skilled workers who had been working in the textile industry in Colombia, they proved to be excellent workers. According to Giuttari, the idea quickly caught on, and many other mills in Central Falls and the Blackstone Valley began to recruit Colombian workers to fill the labor shortage in Rhode Island. In the years that followed, business owners from other mills, such as Pontiac and Cadillac, traveled to Medellín and Barranquilla to recruit workers. These men and other workers who followed stopped the textile business in Rhode Island from fading away in the 1960s.

By the mid-1970s, the textile factories had stopped recruiting Colombian labor. However, a steady flow of family and friends from Colombia continued to make its way to Rhode Island for the next ten years. Many Colombians began to come to Rhode Island from New York in search of the proverbial peaceful life. Employment opportunities here were good, and the promise of a good education, the opportunity to start a business and reunification with family were just some of the reasons for coming to Rhode Island. The promise of jobs was still available to the Colombians who came to Central Falls, and many of the mills continued to employ generations of families because they proved to be hardworking and dedicated.

In the mid-1980s, however, all that changed when most of the mills and factories began to slow down their production, and the owners were forced to lay off hundreds of workers as they prepared for the businesses to shut down for good. This posed an especially difficult problem for Colombians employed at these factories. As a result, many of these workers began moving to North and South Carolina, where it was rumored that the textile mills there were looking for workers. However, it was especially difficult for those who had come in the early years because they did not feel like uprooting their families for a second time.

Another issue they faced was the fact that despite having lived in America for almost fifteen years before the factories began closing down, they still had not had the opportunity to learn English, nor did they feel it was necessary. One of the men who came to work at Lyon Fabrics in the mid-1960s was Bernardo Chamorro, who said that he had spent so much time with other Colombians at work, at home and socializing that he never felt the need to learn English. Anyone who walked through the mills on any given day could hear the buzzing of the Spanish language as the workers busied themselves with their daily tasks.

Many individuals, such as Valentín Ríos and others, did not, however, believe that their lives were over when the mills began to close down. Instead,

Mayor James Diossa. *Photo by Marta V. Martínez.*

they saw this as an opportunity to seek new skills, including the learning of the English language. Many of the children of the early Colombian families who grew up in Central Falls saw this as an opportunity to receive an undergraduate degree or higher and to seek better opportunities for themselves and their families.

In the 1980s and 1990s, the Colombian community of Rhode Island continued to grow steadily, with Central Falls remaining as its destination whether it be directly from Colombia or from places like Florida, where a number of Colombians who were living felt it was time to be reunited with families in Rhode Island. Businesses grew to the point that one could walk down Dexter or Broad Streets in Central Falls and find Spanish-language signs boasting Colombian-owned markets, restaurants, bakeries, record stores, beauty salons and even a social service agency founded by Colombians. Cultural organizations such as the Colombo-American Association were formed, and the local Catholic and Episcopal churches began holding religious services entirely in Spanish.

The development of the Colombian community in Central Falls has brought a large increase in its numbers. While the early Colombian settlers came to Central Falls to make a living, they did not plan to establish an enclave. Today, however, the Colombians are very much an established part of Central Falls, and the children and grandchildren of the first families in the city are in a better position to organize their community and promote

their culture while seeking a greater presence in the larger American society. In the fall of 2001, Latinos in Central Falls were instrumental in the election of the first Latino councilman in city hall. In 2012, history was once again made in Rhode Island when Central Falls residents elected the first Latino mayor, as well as in 2013, when three more Latinos were elected to the Central Falls City Council. This is indeed a message to the greater community of Rhode Island that Latinos have voting power and are definitely here to stay.

THE GUATEMALANS

One cannot talk about the history of the Guatemalan community without mentioning the Guatemalan Mayans, who have been trapped in the middle of a civil war since the 1950s. The civil war started when the United States helped overthrow the Socialist government of Jacóbo Arbenz Guzmán. Arbenz and his government were taking land away from the United Fruit Company, a United States–owned export company, to distribute it to the poor peasants of Guatemala. Many local people opposed the government, which was put into place with U.S. support. The new government death squads killed thousands of people for supporting the "guerrilla forces" or for refusing to support the local government. Because of the violence and economic problems caused by the civil war, about 250,000 people fled Guatemala in the 1980s in search of a more stable place to live. For many, the United States was a place to gain economic security and safety. People fled their homes vowing to return after the civil war ended or after they gained financial security. Popular destinations were Los Angeles, Chicago and New York, and a popular destination for many Mayans has turned out to be Indiantown, Florida, a community of industrial textile workers.

Many refugees were taken in by the Catholic Church, which gave them sanctuary. The sanctuary movement for these refugees was started at the border between Texas and Mexico in the 1980s in an effort to raise awareness about the political situation in Central America. It quickly spread northward and made its way to New England.

For many Guatemalans, Rhode Island became a passing point on the way to political asylum in Canada; it became simply a temporary stopover. In the 1980s and '90s, the Guatemalan community became more visible, settling in places like Providence, Pawtucket, Central Falls and Woonsocket. Today,

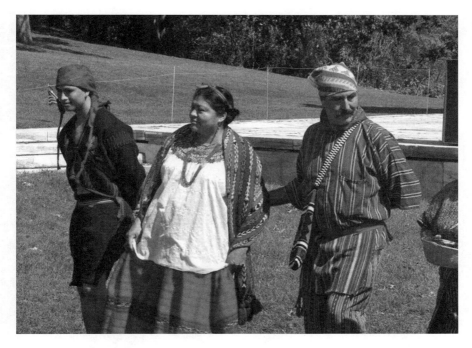

Photo by Marta V. Martínez.

Guatemalans can also be found in large numbers in Aquidneck Island (primarily Portsmouth and Middletown) working in nurseries and running their own lawn care businesses.

When Guatemalans first began to settle in Rhode Island, one of the biggest attractions for them was that it was a peaceful place, especially compared to cities like New York and Los Angeles. Many of the first Guatemalans to reach Rhode Island were from small farming communities, and the rural feeling of Rhode Island—particularly Aquidneck Island—made them feel very much at home.

The first reported Guatemalans began to arrive in New England in the early to mid-1960s. Those were the years of the civil rights movement, and many women and African Americans were moving out of jobs as domestic workers into better-paying jobs. There was a need to fill these abandoned positions, and employment agencies in Boston reached out as far as Guatemala searching for domestic workers. By the 1960s, many Guatemalan women had found their way to Providence as city life in Boston became too overwhelming and as their families from Guatemala began to join them. At

José Gabriel Toledo. *Courtesy Astrid Toledo.*

that time, the Guatemalans who arrived in Rhode Island found very few Hispanics living here. The only support that was available to them were the limited services offered by the Catholic Church. Many Guatemalans expressed their feelings of isolation to the Latino Oral History Project as they sought places to speak their language or looked for the familiar foods that they needed to cook their native dishes. The only Hispanic business where they found a bit of comfort was a place called Fefa's Market, a market in South Providence (owned by Josefina Rosario) that sold many Latin

American staples. Eventually, Guatemalans looking for food that reminded them of home ended up at Roger Williams Park, where one Guatemalan family was said to have pulled up a truck once a week to sell tortillas.

A Guatemalan woman interviewed for this project—who considers herself and her family to be one of the first to arrive in Rhode Island in 1962—shared her story of feeling lonely and isolated. Because of her undocumented status when she and her family reached Rhode Island, she remembers very little about her life in the West End of Providence, where she and her family lived in hiding in the home of a friend for almost two years. Even at the age of eight, she recalls living in fear that they would be discovered by authorities, and the loneliness sometimes led her to wish that she could return to her country just so she could not be afraid every time she would leave her home. During her interview, she commented on the irony of hearing her parents talk about coming to America to find a more stable place to live, a place where they could gain economic security and safety and be free to walk the streets without fear of government oppression. At that time, the Latino Oral History Project of Rhode Island was told of three such families from Guatemala who had been brought to Rhode Island through the Catholic Church, an organization that at the time was not readily prepared to give them the appropriate services needed to become contributing citizens of the United States.

Formal records show that during the 1970s and '80s, Guatemalans began to settle in large numbers in the West End neighborhood of Providence, as well as in Olneyville—on Westminister Street and in the vicinity of St. Teresa's Catholic Church on Manton Avenue, where a Spanish Mass held every Sunday made them feel at home. The areas around Broadway Street in Providence, just east of Olneyville, are also heavily populated with Guatemalans. There are also pockets of Guatemalans in northern Rhode Island, in places like Central Falls and Woonsocket. Remarkably, in North Providence, a small community was developed in the 1990s that includes Quiché-speaking Mayans, an interesting phenomenon that raised a new set of social barriers for this community.

Overall, the Guatemalan community today lives quietly in Rhode Island and still relies on some assistance from the Catholic Church and other social service agencies. There is now a Guatemalan Consulate Office in Olneyville, and the community has formed cultural organizations in an effort to educate the community about issues of amnesty and immigration reform. A number of restaurants and markets that sell Guatemalan foods are now serving the large number of Guatemalans who live in Providence and Central Falls.

According to one Guatemalan who shared her story and who has lived in Rhode Island since the 1960s, the Guatemalan community today is still somewhat isolated. Many individuals hesitate to get involved in political advocacy or find it hard to access state social services for which they qualify primarily because they are accustomed to fearing anything public or government sponsored. There is, however, promise in one individual of Guatemalan heritage who was first appointed a housing judge in Providence and then threw his hat into the race for mayor of Providence in 2014. The future looks very promising for Latinos in Rhode Island in general, and Guatemalans are rising up to join other Latinos to take their place in local Latino political history.

THE MEXICANS

The Mexican immigration to the United States between 1890 and 1965 has been called one of the most significant demographic phenomena in the history of the Americas. This Mexican migration took many forms and contributed greatly to the growth and development of the United States as a nation. The first movement to El Norte (the north) took place after the 1910 revolution in Mexico, when farmhands, shepherds, miners and cowboys felt a call to go north in search of better and higher-paying work. Poor men and women who were unable to find decent work within their borders sought to travel northward. They left Mexico looking for a land of milk and honey, where they could raise their children properly and prosperously.

Mexicans began relocating first to the Southwest United States to find employment, taking advantage of their agricultural traditions wherever they could. However, with the expansion of the railroads in the early 1920s and with the shortage of labor workers caused by World War II, Mexicans took advantage of growth of the railroad system and went to work as track maintenance workers around the country. Between 1920 and 1930, a large migration began to take place from the Southwest to industrial cities all across America. Mexicans not only began to find employment in agriculture and steel factories in the Midwest, but they also found jobs with companies farther north such as the Baltimore and Ohio Railroad Company and in Pennsylvania.

The earliest documented evidence of the Mexican community in Rhode Island is from a headline of a 1938 article in the *Providence Journal* that stated that there were "not more than 15 Mexicans in Rhode Island." The story

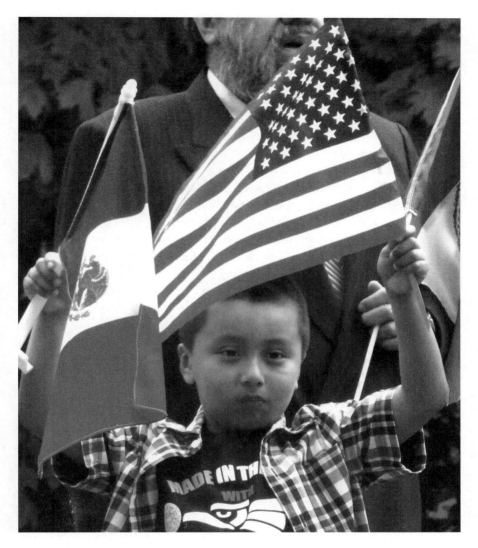

Photo by Marta V. Martínez.

continued and reported that "brisk business with that country" warranted the appointment of Edgar L. Burchell as Mexican consul in Rhode Island. Having been appointed in 1924, fourteen years prior to this article, Burchell set up an office at 42 Westminster Street in Providence, where he also served as "immigration officer, diplomat, tourist agent and tax collector." According to the article, Burchell was the first Mexican consul in Rhode Island.

Burchell's consulate covered Rhode Island and the city of Fall River but had concurrent jurisdiction all over New England. Rather than make the trip to Boston, where the only other Mexican Consulate in New England was located, many Mexicans or Americans looking to travel to Mexico came to his office for a number of services they needed.

The article went on to note, "It doesn't seem strange to Mr. Burchell that there are so few Mexicans in the state. What is strange to him is that there are any at all. There are large Mexican colonies in such cities as Detroit and Chicago, drawn by such well-advertised opportunities as the automobile industry and the stockyards."

Where other consulates, representing the interest of thousands of foreign-born, are constantly besieged for advice and help, in 1938, Burchell reported that only five Mexican nationals visited the Westminster Street consulate that year. All were in trouble, seeking aid. The story added that "Mr. Burchell obtained hospitalization for one who needed it; got jobs for two others and the other two homesick for their native land he repatriated."

By the mid-1940s, research shows no signs of a Mexican Consulate Office in Providence, so it is assumed that Mr. Burchell and the U.S. government no longer felt the need to keep it open. Research shows that to date, that has been the only Mexican Consulate in the state.

The Bracero Program

World War II fueled migration by Latinos to the United States. As defense industries grew and many workers went off to war, industries experienced acute labor shortages. Temporary workers were brought from Puerto Rico and Mexico through the *bracero* program, a 1942 labor agreement between the United States and Mexico.

Although the *bracero* program brought Mexicans to the United States to work primarily in agriculture, some workers were also employed in various industries. More than 100,000 contracts were signed between 1943 and 1945 to recruit and transport Mexican workers to cities all around the United States for employment on the railroads.

A newspaper article in 1944 showed that Rhode Island got its share of Mexicans from the *bracero* program to work on the New Haven Railroad. In January 1944, the *Providence Journal-Bulletin* noted that "60 importations from South of the Border settled down at a labor camp in East Greenwich...to help meet a labor shortage suffered by the railroad in this area." By March of that

same year, another eighty-two Mexicans had arrived to alleviate the manpower shortage of railroad workers not only in Rhode Island but also in neighboring states—ninety-seven of the total men who had arrived were assigned to engine house duties in Providence, East Hartford, Springfield and New Haven, and the rest were put to work in East Greenwich "engaged in track maintenance work."

Unlike in other cities, where it was reported that Mexican laborers were found living in substandard conditions in "boxcar camps," the newspaper article noted that the Rhode Island laborers, who were given a six-month contract, lived twenty to a large dormitory, reportedly slept in comfortable "double-deck bunks" and were provided "a hearty meal" on a daily basis.

Agriculture Workers

In the 1940s and '50s, there was an abundance of jobs in meatpacking plants, utility companies, construction, trucking and eventually in agricultural trades such as sugar beet fields in Michigan and tobacco, vegetable and fruit fields in New England. These jobs were the kind that did not require special skills or the ability to speak English. Rhode Island had its share of agricultural farms in South County and Middletown during this time, and with it came a need for cheap labor and dedication. Mexican workers and other non-English-speaking immigrants, who were available to provide this labor, were hired to do this work. Research finds that farms in North Kingstown, Middletown and Portsmouth employed seasonal migrant field workers from Puerto Rico and Mexico. Today, that practice continues, but the workers in these farms hail mainly from Guatemala and other Central American countries.

The 1980s and NAFTA

Since the turn of the century, textile production has played an important role in the gross domestic product of Mexico. Textile production includes the making of thread, cloth and decoration, in both natural and synthetic fibers. From the end of the Mexican Revolution to the mid-2000s, textile production, particularly lacework, saw steady growth. Much of the growth in the last four decades was spearheaded by "maquiladoras," or manufacturing plants, along the northern border.

Mexico gained advantages in the lacemaking and textile market in the 1990s when the United States signed the North American Free Trade

Agreement (NAFTA). In 2004, all restrictions and quotas on Mexican textiles were lifted in the United States. Unfortunately for Rhode Island, it was then that much of the local textile and lacemaking industry began to fold, when local factories moved to border cities in Texas and California.

Rhode Island Lace Works

Forty-year-old Gilberto García was born in Nicolas Romero, Mexico, and was living in Naucalpan, Mexico, when he moved to Rhode Island in October 1987.

He was recruited by fellow Mexican Roberto Calzada, who was working for the Rhode Island Lace Works company in Barrington, Rhode Island. Calzada was sent to Naucalpan to recruit workers who were skilled in using new lacemaking machinery that had recently been acquired by Rhode Island Lace Works. García had been a lace worker for twenty-seven years in Naucalpan and was very skilled, so he decided to come to Rhode Island to lend a hand. His plan was to stay four years and then return to Mexico.

When he arrived in Rhode Island, he was connected with four other Mexicans who had also arrived the previous day. According to García, they lived together in a "very large apartment" in Warren, Rhode Island.

García said that when he first arrived, he was amazed at what he saw in Rhode Island—especially how clean and "nice" it was here compared to what he was used to in Mexico. He often tried to go out and explore, but he could not get any of his companions/roommates to go with him; they preferred to stay home, watch television and were generally afraid or uncomfortable venturing out because of language barrier and cultural insecurities. García said that they told him they did not want to be hassled, so they kept to themselves. Of course, there was the weather, which none of the Mexicans was accustomed to and which added to the reasons why the others stayed indoors most of the time. García, however, did not let any of that stop him, and he often made an effort to go into Providence to explore his temporary home. During these adventures around Rhode Island, he also started to learn some English and began to like living here.

After four years, Rhode Island Lace Works closed in 1991. García prolonged his stay in Rhode Island when he and his companions were sent to work at Seekonk Lace in Seekonk, Massachusetts. They also worked at the Rhode Island factory of Seekonk Lace in Pawtucket. By the end of the year, García went to work at Frontier Lace (now Frontier Manufacturing)

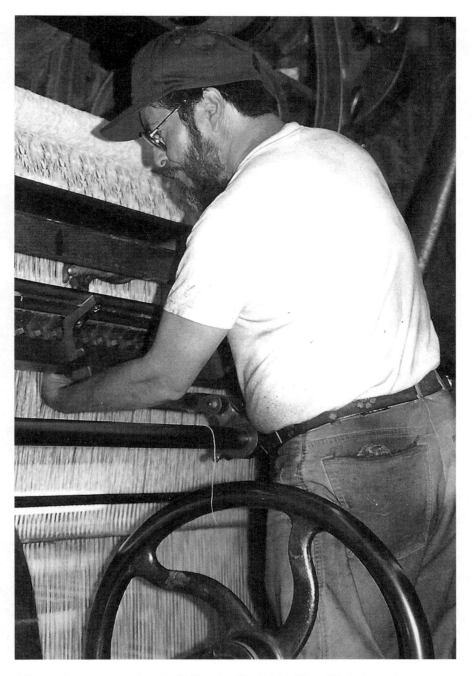

Gilberto García sets up a loom in 1986 at the Rhode Island Lace Works in Barrington, Rhode Island. *Courtesy Gilberto García.*

on Hopkins Hill in Coventry, Rhode Island. After that, he went to work in Perkins Lace in North Kingstown (Quonset).

"In those days, the lace business in Rhode Island was a thriving business," said García. But soon all the factories went out of business when machinery was updated, and they became what García referred to as "electronic." It was then that workers were no longer needed to run the old machinery; the lace business changed, and unfortunately factories began to close.

What also effected this change, added García, was the signing of NAFTA, which, like for many other such industries in America, eventually lead to the end of the textile and lacemaking industry in Rhode Island, sending this work to border cities, where maquiladora workers produced the work for less money.

Eventually, García left the lace business and decided to stay in Rhode Island. He took ESL classes at *Progreso Latino* in Central Falls, became a Certified Nursing Assistant (CNA) and eventually married. Today, he still lives in Barrington.

As for his Mexican companions, García says that he lost track of them and does not know where they ended up. "I suspect some went home because I remember how homesick they were," he said.

THE HISTORY OF LATINO COMMUNITY SOCIAL ACTIVISM AND POLITICAL GROWTH IN RHODE ISLAND

When Latin Americans first began to arrive in Providence in the 1950s and 1960s, the very small community was met with minimal recognition on the part of the bureaucracy. People did not have access to basic social services, and without knowing how the system operated, there was no way for them to attain access. There were, however, specific dedicated individuals, such as Josefina Rosario (in the 1950s and '60s), the Salaberts from Cuba (1960s) and Juanita Sánchez (in the 1970s, '80s and '90s), who worked to make the transition to life in America as easy as possible. These individuals cultivated a community that did its best to support its members by creating informal support systems. These networks were community based and completely isolated from government or bureaucracy.

In an interview conducted for this project, Josefina Rosario, known affectionately as Doña Fefa, is quoted as saying, "I strongly believe that my family and I were the first Dominican family to live in Providence, and maybe Rhode Island." She arrived with her husband, Tony (who was from Puerto Rico), in 1956 and eventually opened Fefa's Market, the first Latino market in Rhode Island. She later added a small restaurant in the back of the market, which served the favorite dishes of the fast-growing Dominican and Latino communities of the time. Fefa and Tony began to sponsor immigrants arriving from the Dominican Republic, and these newcomers would stay with them until they found a job and subsequently a place of their own.

According to Doña Fefa, Dominicans started coming to Providence in the early 1960s in order to escape Rafael Trujillo's extreme dictatorship. One

Josefina Rosario visits the Fefa's Market exhibition created at the Providence Children's Museum in 2004 with the help of Marta V. Martínez (pictured at left). *Courtesy the author.*

Juanita Sánchez in the1980s. *Courtesy Antonio Sánchez.*

important fact that the Rosario family never realized at the time was that they did not merely open the first Latino market in Rhode Island; rather, their store became the first central place for Hispanics to gather and receive important information—like an informal community and social service center. Fefa and Tony, by way of Fefa's Market, provided a place where newly arrived Dominicans could read news from their homelands through the Dominican newspapers that were delivered there; receive translation services (through the Rosarios' three daughters, who were fluent in English); get directions to city hall or to the Employment Office; and, of course, eat and drink their favorite foods from back home, listen to Latin music, play Dominos and comfortably speak Spanish with one another.

Juanita Sánchez, who was also a native of the Dominican Republic, became a strong driving force in the informal organization of the Latino community during the 1970s and '80s. Before her untimely death in 1992, she was a healthcare outreach worker at the Allen Berry Health Center in Providence, and she personally saw to it that new Hispanic immigrants received the healthcare they required and that their Latino children were in school and receiving a good education. In an oral history interview, one narrator recounts a personal anecdote about Sánchez's affect on his own family. When his mother arrived in Providence from the Dominican Republic in 1981, she had serious health problems, but being undocumented, she had no access to care. When his mother went to the Allenberry Health Center, Sánchez saw to it that she received treatment right away. She was given a bed at the hospital and operated on immediately, according to Victor Capellán's 2000 interview:

> *My mom was at the hospital for 32 days…and my family at that time here was my uncle and his wife. And they were working both two shifts, so they couldn't even…they'd go and see her once in while on the weekend. But every single day, the person who went to see her and translate for her and make sure she had her medicine was Juanita Sánchez. So that was the kind of work that she did. She was the CHisPA, herself. She was an institution.*

For more than ten years, Sánchez's picture hung on the wall of the Center for Hispanic Policy and Advocacy (CHisPA), located at 421 Elmwood Avenue in Providence; the building, with the help of Marta V. Martínez and Luis Aponte, was acquired for the Latino community and named in Sánchez's honor. After her death, the first community endowment fund for Latinos in the state was set up at the Rhode Island Foundation, and in 2004, a school

Marta V. Martínez, executive director of HSSA, and Juanita Sánchez, the organization's chairwoman, during the 1990s. *Courtesy* Providence Journal.

building was named after her. Today, Doña Fefa also continues to enjoy her place in Rhode Island Latino history, with many honors bestowed on her by her extended Latino family. As for the Salabert family, who founded the first Cuban Club of Rhode Island, the elder Salaberts have since passed away after moving to Florida, but the daughters, Miriam (Gorriaran) and Tessie, continue to stay involved in the Latino community through their volunteer work and serving on the boards of community organizations.

RHODE ISLAND'S FIRST LATINO SOCIAL SERVICE AGENCIES

The beginnings of community organizing in Providence obviously did not solely consist of the work of these two women or the Salaberts. Their stories, however, provide a clear example of the support systems that were being put into place in the early days, as well as the amazing opportunities

that became possible as the community began to familiarize itself with a foreign landscape.

In the early 1970s, the Latino community began to come together to organize in an attempt to gain access to social services. The work of pioneers such as Doña Fefa and Juanita Sánchez laid a foundation, but individuals can only do so much, and soon people began to realize the need to form organizations much like the Cuban Club of the early 1960s. In 1970, this need was answered in the form of the Latin American Community Center (LACC), which was supported and encouraged by the Catholic Diocese of Providence.

Located at 3 Harvard Avenue, LACC opened its doors on October 25, 1970, with the help of board president-elect Arturo Liz and Reverend Raymond Tetreault, director of the Latin American Apostolate of Rhode Island. Mercedes Messier was appointed as the organization's first executive director. Much like Fefa's Market in the early 1960s, the center served as a problem-solving agency, and its main purpose was to help Latinos adjust to life in America. Many of the new immigrants could not speak English, so they had no way of finding ways to fulfill basic needs. The center provided a place where they could go and explain their difficulties, and the staff would refer them to the appropriate city or state agency for service. LACC's staff also helped find jobs for newcomers and offered English language classes for both adults and children. Aside from these crucial social services, a 1970 *Providence Journal* article described the center as a means for bringing together people from different Spanish-speaking countries, including Honduras, Guatemala, the Dominican Republic, Cuba, Puerto Rico, Bolivia, Colombia, Uruguay and Venezuela. Unlike many other cities' ethnic communities in the United States, the Providence Latino community is a relatively cohesive group, and early efforts such as this community center are a possible explanation for this.

By providing a physical space for people to congregate, contacts were formed that then led to the creation of alliances and formal social service organizations. These organizations were community based and not political. In the words of Juán Francísco, one of Rhode Island's early Latino activists:

> *Politics were, for us, at that time, very non-existent, and it was more at the level of community organizations that evolved through the Catholic Church and independent movements that we concentrated our efforts. Not necessarily directly involved in the political arena because we felt that we were not wanted there. We felt like outsiders. But at the same time, we also felt that we needed to do something to exert our rights, to advocate and to protect the community on a number of issues that we felt were very important.*

After a successful beginning and much activity, it was unfortunate when, due to financial difficulties, LACC was forced to close its doors in 1974. It was then that the task of mobilizing the community fell on the shoulders of a small group of Latinos that had worked hard to gain access and understanding.

Juán Francísco was one of a group of pioneers that led these community mobilization efforts. This group included Olga Escobar, Rosario Peña, Zoila Guerra, Victor Mendóza, José González, Roberto González, Manuel Jiménez and José Alemán, to name a few. Through the work of these pioneers, three central organizations were created, and this formed what later became the Coalition of Hispanic Organizations (CHO).

The first group in the coalition was *Club Juveníl*, a youth group that focused on education and also arranged social gatherings such as sporting events. The second, *Orientación Hispana*, of which Manuel Jiménez was president, worked with the elderly. The third, *Acción Hispana*, was chaired by Juán Francísco. *Acción* was the product of efforts by the Catholic Church after LACC closed, and its first location was in the basement of St. Michael's Church, located on Oxford Street in South Providence. It was an issue-oriented group that provided basic social services. Members of the community could bring their specific problems to the organization and have them solved on an individual basis. These three organizations created a foundation of services and attempted to cover and provide access for the entire Latino community.

Other organizations, such as *Proyecto Persona*, developed from this base. Much like the Latin American Community Center, *Persona* was a United Way–funded agency that, according to a 1974 *Providence Journal* article, acted as a "cultural haven for people trying to adjust smoothly to a new way of life in the United States." *Persona* was managed in conjunction with the Providence Public Library, and its initial goal was to give Latinos a safe and familiar environment to learn English. It quickly expanded, however, and was soon providing film workshops, training for high school equivalency tests and recreational activities. It also arranged discussion groups for Latina mothers, who often had a harder time acculturating to American ways and meeting people because they were not in school or at work. In the 1980s, *Proyecto Persona* became part of the International Institute of Rhode Island and moved under its roof at the Trinity Church on the corner of Broad Street and Elmwood Avenue.

As these organizations began to emerge, the demand for the services that they provided also continued to increase. As members of the Latino community became aware of their rights, they also began to feel a need

Groups like *Proyecto Esperanza* and the Hispanic Social Services Committee (pictured here) held weekly meetings in support of issues affecting Latinos in the 1970s, '80s and '90s. *Courtesy International Institute of Rhode Island.*

to be political participants, a desire that these nonprofit institutions were unable to fulfill. Nonetheless, the organizations did make important steps in the development of a cohesive communal identity and provided the space both physically and institutionally for the evolution of a growing political consciousness.

LATINO SOCIAL ACTIVISM BEGINS TO TAKE SHAPE

The organizational structure of the CHO was similar to a loose confederation of the preexisting organizations. The coalition consisted of *Acción Hispana, Orientación Hispana, Club Juvenil* and assorted programs. Juán López, who in the 1990s became a member of the Providence School Board, was hired to coordinate youth services, while Juán Francísco and Manuel Jiménez headed *Acción* and *Orientación*, respectively. Each organization maintained its own

leadership and board of directors in addition to the two representatives it sent to the central board of the coalition.

The actual reason for the coalition's existence was one, abstractly, of idealism and, practically, of funding. Each organization had been competing for what little existed of foundation and government operating grants, thus fragmenting the organized arm of the community. United Way began to pressure existing Hispanic organizations to consolidate by threatening to withhold funding from distinct Latino organizations, and it was this act that gave impetus to claims for unification.

In addition to providing services to the community, the coalition began to "confront the very sobering experience of dealing with the political structure." The role of advocate meant constant communication with the political arena, often in the domain of bilingual access and representation, according to Victor Mendóza in a 2000 interview:

> *We fought very hard…that* [CHO] *was the agency that gave respect to the community. That was the agency that fought the police against brutality. That was the agency that informed the majority of all the issues that were affecting the Latino community at that time. That was the agency that fought the hospital that did not have any bilingual workers. That was the agency who fought the school department to have some representation of teachers.*

In addition to frequent advocacy, the coalition pressed for permanent institutional representatives to be present within the community. In a similar vein of political activism, a network of support internal to the political and professional arena evolved. For those within the system, the coalition also advocated on an individual level in much the same manner as the Hispanic Social Services Association (the predecessor to CHisPA) would do throughout the '80s and early '90s.

POLITICAL ADVOCACY

The appearance of a functioning Coalition of Hispanic Organizations in 1976 indicated the first signs of politicization of the existing organizational framework for the Latino community in general.

The incorporation of these three existing Latino organizations into a coalition meant governmental funding and a newly found unity and legitimacy for the Latino political pioneers. Social services previously provided by individual organizations were partially subsumed within programs of the coalition. More distinctly, the first sustainable bridge was formed between the Latino community and the political arena. The appearance of advocacy as an oversight, as an external watchdog and challenge to the public service institutions, heralded the beginnings of a Latino political consciousness. The coalition's existence signaled that the Latino community would no longer solely bear the responsibility of support (at least in principle). Bilingual services in health, education, housing, employment and basic public utilities were a right that the political arena was obligated to perform. Advocacy meant forcing those in power to acknowledge those obligations.

The coalition's first contacts with the government were through the Providence Community Action Program (PROCAP), a Providence-based municipal agency in charge of funding community organizations. The Latino community already had "political capital" with the presence of María Matías and Alma Green, the latter being the funding coordinator of PROCAP and an organizing force. Green was an active and central participant in *Acción Hispana*, which by then worked out of Central Falls. In the context of federally funded anti-poverty dollars, the coalition also received funding from the VISTA program in the form of compensated employees. In this manner, the coordinators of the various programs existing within the coalition were funded by the federal government. Just as young, rising Hispanic leaders like Roberto and José González in Providence and Patricia Martínez in Central Falls entered as VISTA volunteers, others were now being encouraged to help organize the community.

The political arm of the Latino community was also being strengthened through coalition activity. In the late 1970s, ties to the bureaucracy and service institutions of the state were soon supplemented with ties to the elected officials who appointed bureaucratic leaders and made policy. In keeping with the clientele-focused atmosphere of urban politics, political consciousness took on a certain savvy. Bonds were formed with elected officials on the part of a select group of leaders, while votes were promised in exchange for concrete benefits and temporary empowerment. Latino politicians had situated themselves at the periphery of the political arena as power brokers, conduits of power between that arena and the community itself, as Francísco noted in 2000: "So that's how our whole experience began, and that [CHO] was how we got to be in touch with the political

system and realize that we needed to protect ourselves. And so we began to...stick our head out, so to speak, into the political landscape."

The political landscape of the 1970s was on the most local level, the patronage based on the context of Democratic ward politics. Lloyd Griffin, who was one of two ward councilmen in that area, dominated the ward encompassing much of the Latino community. His political machine both limited access and provided a strong model for the ins and outs of political execution. The value of a nascent Latino voting bloc as a building block of political power was often exchanged for token gestures of limited representation and access.

But something was lacking with this arrangement. True political empowerment meant direct access to services and not indirect benefits through a tenuous patron-client relationship. The evolving and hungry Latin American political community wanted independent, sustainable power within the political arena—not just outside of it. Institutional representation meant using not just political savvy but also clout to secure substantive appointments within the public-service institutions.

Vincent "Buddy" Cianci first successfully ran for mayor of Providence in 1975 on the Republican ticket and had managed to co-opt the Democratic machine. The bond between Mayor Cianci and the Latino coalition leadership yielded the community's first political appointment, that of Roberto González to the Providence School Board in 1978. Unfortunately, the strength of the coalition was to be dismantled only a year later. From most accounts, the demise of the coalition was a matter of ego, both organizational and individual. The semi-independent structure lent itself quite easily to intra-organizational competition within the central board of the coalition. The election of Manuel Jiménez as director of the entire coalition caused resentment on the parts of those who felt underrepresented. According to some, a certain political immaturity and inexperience with the democratic consensus decision-making of a committee only worsened matters.

Not everyone felt that the closing of the coalition was a bad thing. According to another early activist, it was the beginning of what he felt was "destiny."

The dismantling of the coalition meant the fragmentation of the organized Latino political community. *Orientación Hispana* and *Club Juvenil* were the fist casualties of the breakup. Co-founders and Colombian community organizers took the services of *Acción Hispana* to Central Falls in 1977, where it eventually incorporated and made the transformation into *Progreso Latino*. This fragmentation and subsequent retreat caused an organizational vacuum

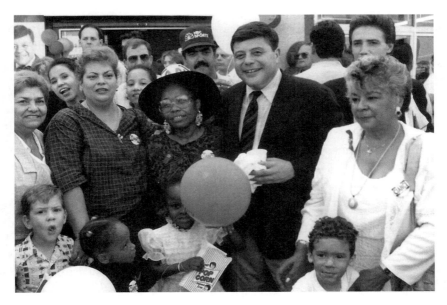

Doña Fefa rallies the Puerto Rican community in Providence to support candidate for mayor Vincent "Buddy" Cianci in the 1970s. *Courtesy Josefina Rosario.*

Patricia Martínez with an ESL student at *Progreso Latino*, a social service agency founded in Central Falls, Rhode Island. *Photo by Marta V. Martínez.*

of sorts. By early 1980, *Coalición Hispana* ceased to exist, and that same year, the Hispanic Social Services Committee (HSSC) was formed, according to Roberto González in his 2007 interview:

> *When* [Coalición] *finally closed down it almost splintered. Actually, when I think of it, the Coalition may have ended, but the different groups started to take on lives of their own, like children growing up and developing. So, one group went to a building on Niagara Street in Providence and established themselves there. Another group went to work with the Dominican community. Another group started doing the parade, etc. So, in essence, Coalición didn't actually die, but I think what happened was that everything became what they were destined to be.*

The consolidation of Latino political consciousness and gains in access, however, were not to be lost so early. The state senatorial campaign of Charles Walton against Lloyd Griffin possessed heavy Latino involvement. People were registered to vote and informed of the issues as Walton was introduced to the community. The increased activity of the Hispanic Social Services Association managed to secure a position for newly arrived Dr. Pablo Rodríguez within the Rhode Island Department of Health. Overall, pressure for access and representation-services from and jobs within the bureaucracy was maintained. The campaigns of J. Joseph Garrahy and Richard Licht for governor and lieutenant governor, respectively, secured the appointment of Margarita Baez (one of the founders of HSSA) to a state-level position. For many years, she was the only Latina who had access to the statehouse. When the leaders wanted to be apprised of what bill was on the floor and who needed to be lobbied, the information was communicated through Margarita. Later appointments of Olga Noguéra to the Rhode Island Department of Human Services, Victor Mendóza to the Personnel Department and Juán Francísco to the Providence School Board further strengthened the institutional representation of Latinos in the political arena.

PART V
THE PIONEERS

JOSEFINA "DOÑA FEFA" ROSARIO

Josefina Rosario, affectionately known as "Doña Fefa" among generations of Dominicans who currently live in Rhode Island, has been credited with launching the first wave of immigration from the Dominican Republic, beginning as early as 1955. She and her husband, Tony, are remembered by many people who say they sponsored their families to come to the United States, gave them free room and board until they were able to find jobs and made sure that they had everything they needed.

In 1930, Rafael Trujillo came to power in the Dominican Republic and established one of the longest-lasting dictatorships in Latin America. It endured until 1961, when he died. It was during Trujillo's reign of terror that many Dominicans, fearing that they would be killed by Trujillo's men, first began to flee the Dominican Republic for the United States.

Doña Fefa was personally affected by Trujillo's power when, in 1937, her father was murdered by secret servicemen while recovering in the hospital from gunshot wounds. Her mother was left alone to raise ten children and later became paralyzed when she suffered a stroke. Fefa, the youngest child, eventually made her way to New York City, where she had an older sister waiting for her and where she met her husband.

Josefina "Fefa" Rosario. *Courtesy Marta V. Martínez.*

I was twenty-one years old when I came to the United States. My sister Minerva del Río was over here, my close sister, she lived in New York. She came here two years before me. She came here to live with my cousin, who invited her to live with her in 1947, to keep her company. She would often write to me, telling me that she missed her family. In her letters, Minerva often told me how she worked hard and how much she missed me. I missed her, too. I remember when she left, I gave her an olive, you know—*una aceituna*. I ate half and I gave the other half to her. I was very close to her. In the old country, that is one of our customs. You share everything with someone you love.

After I left, I remember I missed my mother. I did not want to leave her. I cried, you know. I was happy, yet sad at the same time. I cried because I was leaving my mother and my sisters and my brothers, but I was happy because I wanted to come to the United States to be with my sister.

I remember I didn't bring many clothes because my sister said not to bring too many things. She said, "*No traigas mucha ropa.*" So what I did was I went out and bought some material to make a new dress that I could wear

Fefa stops to pose one last time for a photo while on her way to the airport in Santo Domingo, where she boards a plane to come to America. *Courtesy Josefina Rosario.*

when I came over here. *Mi comadre,* a good friend of mine, helped me make a special dress. I remember, the dress had a *plia rollada.* I remember it had flowers, navy-blue and white. I still have a little picture that somebody took of me wearing that dress.

On the plane, I only carried a small suitcase, like a tote bag. I think it was full of candies, or something, I don't remember exactly. I do remember it was cold when I arrived. Not like Santo Domingo. It was September 8, 1949.

It was hard for me to leave my family behind, especially my mother, who had been paralyzed at the age of 35 when she suffered a stroke. But my mother knew I would be in good hands with my sister in New York. *Ella*

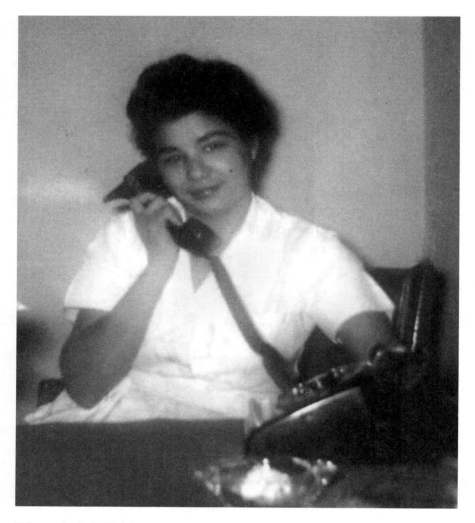

Fefa was the "salad lady" at a restaurant in Connecticut before moving to Rhode Island with her husband, Tony. *Courtesy Josefina Rosario.*

sabía que ya estaba bien cuidada yo, estaré cuidada con mi otra hermana. Y yo sabía que ella estaría en buenas manos con mis hermanos y hermanas allá. And I did not worry because I knew my brothers and sisters would take good care of my mother after I was gone.

Bueno, la primera semana estuve muy contenta aquí, pero despues, me quería ir a mi tierra. I was very happy after my first week here, but after that I wanted to go back home. The shock set in then, *¿Que hize?* What did I do? Oh, where am

I? I remember in her letters, my sister would tell me that I would have to do everything for myself when I first arrived, and she was right. I had to go to work right away, and you know, I did everything here: I even cleaned toilets!

Well, I lived in New York for about seven or eight years. During that time, I met my husband. After I left Santo Domingo and had lived here about a month, I was waiting for the subway to take me to the Bronx one morning. I was going to work. And then, a young man came up to me and asked me, *"De donde eres tú?"* Where do you come from? And I said, "Santo Domingo. I'm waiting for the 241," just like that. And later he told me that and he was impressed that I knew English so well after living here only one month. The truth is, I knew little English. I had simply memorized the numbers of all the trains I took everyday, nothing more than that! It turns out he had been watching me all this time, and that's how he knew I had been here only one month. Very soon after that, he asked me to marry him. *Oh, pero primero fué a hablar con mi hermana.* But not before talking to my sister.

After we were married, Tony worked as a bus boy at Carrullo Restaurant in Manhattan, and I got a job in a factory, making wallets. After a while, Tony was offered a job in Connecticut. We had to commute from New York for a few months after that because we couldn't find an apartment in Connecticut. But as soon as we found one, we moved to New Haven.

My husband got a job working for some Greek people, Constantinopal "Connie" and Mary Gimogine, owners of Les Shaw's Restaurant in New Haven. *Algunos tres o cuatro años estuvimos trabajando con ellos.* We worked for them for about three or four years. Eventually, I got a job with them, too. I started out washing silverware. After a few years, Connie and his wife decided to open a new place over here, in Rhode Island. It was a restaurant located at the Yankee Inn, owned by Johnson and Wales; it was directly across from the airport in Warwick. It was then that we moved here, to Rhode Island: it was 1955. My husband was hired as the cook, and I became the salad lady.

The Rosarios Move to Rhode Island

So, it was these restaurant owners that first brought us to Rhode Island. We knew no one here, had no family. Back then, the Les Shaw's Restaurant was part of a hotel, so we lived there for two months while we looked for a house. We knew no one in Rhode Island.

Entonces de allí, encontramos una casa en la Dexter Street en Providence, y allí nos quedamos por un mes. We finally found a house on Dexter Street in Providence—

the corner of Dexter Street and Potters Avenue. *Pero, era muy pequeña. Despues encontramos una en la Chester Avenue, 145 Chester Avenue.* It was too small for our family, so then we moved to 145 Chester Avenue. That's the Torrigan house, I remember that. It was right across from St. Joseph Hospital, next to Kappy's Liquor Store. It's no longer there. I go by there sometimes and see the empty lot. It's close to the corner of Broad Street and Chester Avenue.

The house had seven rooms, and we paid 45 dollars a month. Imagine that? I helped to paint the house. *Estaba bien limpio. Todos esos judíos vivian allá.* It was a very nice, clean neighborhood. Beautiful. Jewish people owned many of the homes and stores in that neighborhood at the time. Kappy's was a Jewish-owned liquor store; there was also a pizza place and other stores owned by members of the Jewish community.

I strongly believe that my family and I were the first Dominican family to live in Providence, and maybe Rhode Island. I believe that because, in 1956, when we moved from Warwick to Providence—I was pregnant with a baby girl at the time—my husband decided he wanted to open his own Spanish food restaurant where other Hispanics could eat. So, he walked up to a policeman on the street and asked him, "Where do the Dominican people live over here? Where do the Hispanics live? *¿Dónde esta la comunidad Hispana? ¿Dónde viven los Dominicanos?*" The policeman said, "I don't know where the Spanish-speaking people live in Providence, but I know of one Hispanic family in East Providence." My husband asked him, "Where is East Providence?" And he told him to go East, then over a bridge…Anyway, we went over there looking for other Spanish-speaking people, and finally someone there told us about two Hispanics—Puerto Ricans—who were living in East Providence. I asked if there were any Dominicans or more Puerto Ricans, and I was told that there were no other Puerto Ricans over there, no other Hispanics anywhere.

So it was then that we decided that we wanted to open a restaurant in Providence, soon after the Greek people closed down their restaurant; they filed for bankruptcy only after about a year and a half. When that happened, they asked me and my family to go back with them to Connecticut, and my husband said, "I don't want to depend on you all the time. I have a family now and I want to stay here."

About three weeks after Les Shaw's closed, my husband was able to find a job as a cook at Johnson's Hummocks on Allens Avenue—on the corner of Allens and Public. And I became the salad lady there. We worked hard to save our money so we could open our own business.

Eventually, my husband left Johnson's Hummocks to work at the Quidnesset Country Club. And then he worked at the Metacomet Country

Club and eventually at Barrington College. After that he quit because he was tired of working for other people. He was ready to open his own business. A good friend of his, Mr. Adleman, the brother-in-law of the owner of Lynch Liquor Store and another market on Broad Street near our house, loaned him some money to help him open his own grocery store and restaurant.

We got the idea of opening a market soon after we moved to Providence because we would often—almost every weekend—drive to Connecticut in our blue station wagon to buy food for ourselves and for other Dominicans who were living in South Providence with us. Things like *platanos, yuca, café, cilantro...*

Ah, yes I clearly remember that station wagon...We would do that because they didn't have Spanish products here at all. We would drive to New Haven and bring back food and sell it door to door, *como de domicilio*, right there on Chester Avenue.

En Chester Avenue me decían, "Oye Fefa, queremos cuatro plátanos, cilantro, oooh... café Dominicano—Dominican coffee, um"...Others would see me out on the street and invite me over to their house so they could give me their order for Dominican food from Connecticut.

At first, we used to deliver the food door to door. But then it got to the point where more and more people started coming to us. So, I remember, there used to be big parking lot where we lived—behind Torrigan's house— where we would park the car after returning with the food from New Haven. People knew exactly what time we would be returning, and they would be waiting there to get their things; a long line would be waiting for us when we arrived. Yeah, I remember, we used to have a little scale to measure items, the dried goods. Those who did not order things would come anyway to see what we had. They would line up and say, *"Quiero tres plátanos, medio kilo de cilantro, un kilo de habichuelas..."* And that's how they would get their shopping done. It looked like *"Un bento rrillo,"* that's what they would call it. Like those peddlers today who sell fish, sandwiches and *pinchos* right there on Broad Street and Elmwood Avenue. They still do that today.

How did all those Hispanics end up in my neighborhood? Well, immediately after we decided to open a market and started traveling to Connecticut and New York, we would bring back not only food but also Dominican and Puerto Rican friends we had known when we lived there. We had a lot of people living with us in our house, people my husband and I sponsored from Santo Domingo. They stayed with us until they could find their apartment or house. Our house was often very crowded, but we did that so that people could get situated and we would help them find work, schools for their children and then to find their own apartments. The Dominicans were really

right there, on Chester Avenue. That's where it started, you know. We had a sort of boarding house for people who wrote to us from Santo Domingo who wanted to come to the United States, and also from those that came with us from Connecticut or New York. Back then, right there on Chester Avenue, we found temporary lodging for a few families. We would sponsor them and they would stay in Dr. Emerson Torrigan's house. He was a dentist, and I think he's still right there, on Broad Street.

Fefa's Market

Finally, around 1959, when the Hispanic community started growing more and more in Providence, we opened our market on Broad Street—right on the corner of Broad and Bacon. Across from the entrance to Roger Williams Park in Providence, where the little plaza is now. *Once-treinta*, 1130 Broad Street. We called it Fefa's Market. And then, not too much time later, we also opened a restaurant, inside the market.

I remember, there was an *americano* that called my husband "Mr. Feefa." Ha! Yes, I would answer the telephone and he would say, "I want to speak to, eh, Feefa." And I would say, "Well, she's speaking." And he would say, "No, Mister Feefa." And other Americans, they would say "Feefa" instead of "Fefa"!

To this day, people who remember me from those days call me "Doña Fefa." Those families, their children and other relatives who came later to Rhode Island still see me and still remember how I brought them here. Most families started coming here from the Dominican Republic around 1960, and by the mid-'60s, there were around ten families…well, very few of us. After that, between '66 and '69, that's when more and more Hispanics started buying houses. Then they started writing to their families and friends, asking them to come join them in the United States. The Dominican community started slowly growing then, and they began to settle in homes off of Broad Street, and people started to open a few businesses then, too.

It wasn't until the early 1970s when more and more Dominicans and other Hispanics came here in larger numbers. [The year] 1975 is when the dam broke open; when Antonio Guzmán was elected President of the Dominican Republic and many people were afraid to stay in that country. There was a lot of poverty and the economy did not look hopeful in the Dominican Republic, so people wanted to leave. It was about that time that we also bought our first house—62 Lenox Avenue.

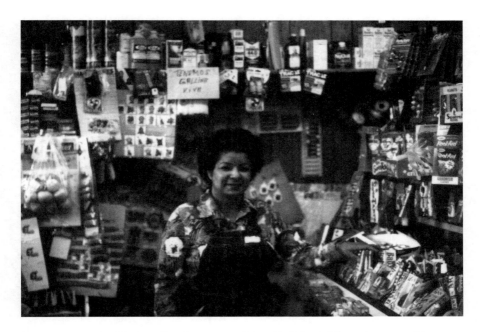

In the 1960s, Fefa's Market offered an array of "goodies" for children who stopped in on their way home after school. *Courtesy Josefina Rosario.*

I will always remember Padre Rubba from Providence College. He helped us, he helped a lot of the Hispanic people in those days. My husband eventually started asking around to see if anyone could help the Hispanic people, especially those that were living in our house. And there was this priest, I think he was a Colombian, Padre Rubba. I remember he gave people beds, he gave people clothes. He especially helped some of my cousins, you know. He got everything for my cousins, and for everybody who said they needed something. He would get a list of what was needed, then would call my husband, Tony, who would go get the items and bring them back and deliver them to whoever needed them.

Pretty soon, people in Providence began to know me and my husband well, and so it was easy for me to go to a business owner and recommend someone for a job. I would even help people get their Social Security card. People trusted me and my husband, and they would help us in whatever way they could. Of course, it was easier back then because there were more jobs available. When someone who was living in our house found a job, I would then ask for 15 dollars a week for room and board, no more than that, until they got settled in their job and were able to find their own apartment.

But it was not always easy. It was a struggle for us and many other Hispanics, as well. Many people had to rely on one another for help. Many of the Dominicans and other Hispanics who had kids that spoke English often had to ask them to interpret when they went out. I would send my own daughters to interpret for many of our friends who needed help while applying for their Social Security card, trying to get a driver's license and things like that. Some people didn't know how to read even in Spanish, so my daughters helped with that, too. Many times, I would take the girls out of school and send them somewhere to interpret for our friends who needed help during business hours. I am very proud of my two daughters Cecilia and Madeline.

Interview by Marta V. Martínez, Juanita Sánchez and Karen Lee Ziner, May 1991.

VICTOR MENDÓZA

I first came to the United States in 1969. I didn't have family when I came here; I came alone. I was 18 years of age when I left home, and I traveled to New York. Eventually, a friend invited me over for the weekend just to visit the family. I came and saw Providence in 1971, and I really liked it. I really enjoyed it.

When I first moved here, I was told that there were some families from Puerto Rico and also from the Dominican Republic—just a few families, you know. They came to Providence attracted by the jewelry industry, and the jewelry industry was very attractive to these people. But you see people follow the family, that's the way the community grows, by family. So you follow your cousin and you follow your brother and you follow your *compadre*, you know, your godfather and stuff like that. So you follow families to come. And so that's the way that the community has grown in Rhode Island. It's not because they wanted to come to Rhode Island because it's a beautiful place. No, they came because they knew someone here.

Soon after I arrived, a group of us first started to organize the community back in 1974. I got involved as soon as I came to Rhode Island; I got involved with the community very soon because I enjoy that very much. See, we come from countries where we have fighting and revolution and protests and dictatorships, so when you come to this country, you come with that

Victor Mendóza. *Photo by Marta V. Martínez.*

mind. Of course you don't come here to fight the system, but when you see the injustices around you, you learn that you need to work within the system in order to get what is right.

In terms of organization, we organized the first coalition of Hispanic activism in the state in 1976. At that time there were two or three organizations for Hispanics: there was a youth organization, it was *Alianza Hispana* or something like that. And then you had the other organization called *Orientación Hispana* that used to take care of the elderly population. Then you had another organization taking care of social issues. So what we essentially did is that we got involved and put together all of these into one coalition because they were confronting problems with funding; they were competing with each other for funding. And the foundations and agencies that were providing funding at that time said they were not going to provide funding until we [Hispanics] organized. So we organized and put together the coalition of Hispanic organizations. That was the strongest

organization we could find. It was so strong that we have not been able to have an organization like that even in the year 2000.

It was especially strong because we had all the leadership and the diversity in the Hispanic community. There were people like Roberto González... he's a judge now; we had Manuel Jiménez, who is now the owner of one of the largest real estate companies in [Providence]; we had people like José González, who is with the Providence school department; and we also had José Alemán, who today is working as an administrator in a high school. Look at the titles of these guys today. These are people who used to be students and look at where they are now! And you also had people like Juán Francísco, who is a top official for the University of Rhode Island now. And another thing that we did at that time is that we forgot about nationality, because sometimes there is no question that there had been some friction over that. I always have that in my mind, I always think about diversity. That has been, if there is something that I would like people to remember me, as part of the work that we all have done is that I have been one who fought for diversity and for equal opportunity for all.

First Latin American Festival of Music in Rhode Island

I organized the first Latino festival in the state. I organized the first one; it was the Latin American Festival of Music in 1979. It was very, very famous and we got 20,000 people in the park. It was through the Hispanic Cultural Arts Committee, an organization that I founded and served as its Chair. Today, the Hispanic Cultural Arts Committee still exists, but it is very, very different—it no longer organizes the Latin American Festival, but it paved the way for other larger festivals in Rhode Island, such as the Dominican Festival, the Puerto Rican Festival and others that take place during the summer months.

Advocating for Education

I remember one time at the Lexington School, one day suddenly in 1974, the principal of the school said that they had to send three or four Hispanic kids to be checked at the hospital because he felt that the kids were having trouble mentally. And you know what the problem was? The main issue was that they couldn't speak the language. They could not understand the language.

First Latin American Cultural Arts Festival at the Temple to Music, Roger Williams Park, 1986. *Courtesy Sam Beck and Marianne Cocchini.*

So that was the time when we started to fight for bilingual education. So a group of us got together and we went to talk to the superintendent of the schools at that time. And to have the superintendent listen to us, that was a big thing. This was a very small group for him to pay attention to. We felt it was a big problem, especially at the time, because the children were being mistreated because of language. And now you know the community has grown tremendously and things have changed, but there are a lot of things to be done.

You see, when you think about Hispanic, you think about the neighborhood. You're not thinking about the people out of the neighborhood who have established themselves outside of the Southside of Providence. You're thinking about the people who are there. These are people who competed to be there for years. Twenty, twenty-five years they run their house, they lived there. And this is a period where the majority, I suspect that the majority who are not Hispanic, think that these are only people who have nothing to contribute to society, and this and that. Only in reality the big majority of the people are very decent people...they live very well. They are living well. Not everybody is in poverty there. There are people who are living well. They send their kid to school every day. They are eating well. They are making some money. They have their cars to drive. They have their insurance. They have their benefits. So not everybody is poor in the south.

Advocating for Basic Services

Well the best thing that I did, my best performance, is when we founded the Coalition of Hispanic Organizations because that was the agency that gave respect to the community. That was the agency that put the name Hispanic high in the state. That was the agency that fought the police against brutality. That was the agency that confronted the mayor with all of the issues that were affecting the community at that time. And that was the agency that fought the hospital...that we didn't have any bilingual workers, that we didn't have any interpreters in the hospital. And that was the agency that fought the school department to have some representation of Hispanic teachers in the system that could serve as a model for the students. I mean, I could tell you so many things that we did there that really affected change because its like fixing, to make sure its fixed right, permanently, you put somebody there to take care of it and put pressure, and the person's going to continue to be there so that others can continue to have some kind of representation.

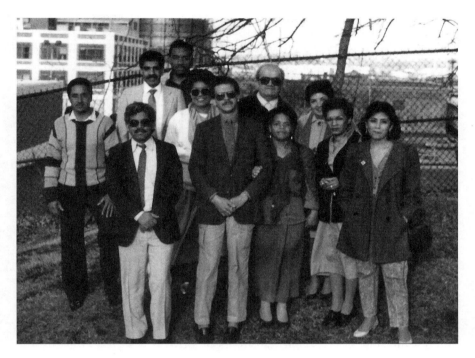

Members of the original Hispanic Political Action Committee, 1986. *Courtesy Reverend Juán Francísco.*

I got involved with politics in the 1970s when the Latino community was still growing. I was one of the founding members of the Hispanic Political Action Committee of Rhode Island, which was the first political organization, and we registered people to vote. I think one of the best things that we did is that we tried to inform the Hispanic community that we shouldn't ever be involved in a one-party system. There are two parties here [in the United States]: one is the Republican and one is the Democrat. And we felt that we didn't have to be affiliated with the Democrat because, the Democrat, the only thing they have done in the state of Rhode Island is taken advantage of the Latinos and the African-Americans. They take us for granted. My colleague, Juán Francísco, ran on the Republican ticket because that was the only offering he got. I ran his campaign, and of course it was difficult. You had this Latino running as a Republican. It was shocking, especially in the [Hispanic] community. But the good thing was that they knew Juán Francísco. So they weren't thinking about Juán Francísco as a Republican, they were thinking…"Look at Juán Francísco the Hispanic, a guy who was concerned with the community." Juán

had some problems with that because there were some Democrats...there were some leaders who were involved with the Democratic Party that didn't think Juán should be running on the Republican ticket. They [the Republican Party] were the only party that wanted him...because when he approached the Democratic Party they said no. I was present at the time. We tried and they said you're not ready to run. They didn't want to give us that opportunity; they wanted to give it to someone else, not to a Latino. And as I said, they continue to take us for granted.

So the HPAC was made up of a lot of people, a diverse group of people. Besides Juán Francísco and me there was Rosario Peña...people from Nicaragua, Colombia, Dominican and Guatemalan. This was a very diverse group of people that composed the Hispanic Political Action Committee. I think that what we did at the end is that we were educating [Hispanic] people so they would participate. We took a chance when we saw the Democratic Party wasn't minding us much and the Republican Party was calling us. And we did support the candidate who was elected governor of the state of Rhode Island. And the records are there. You can see it; it's a public record. 1985 to 1990, that was the period when the majority of Hispanics entered the state government...so many of them that if you compare the amount that entered in those five years with the following 15, you're never going to get close to that number. How did we get those people there? We supported Governor Edward DiPrete at the time, and we were the only minority that was helping him in his campaign. Because the Democratic Party was not paying attention to our needs...taking us for granted and we got these people saying come on I'm going to work with you, we're going to help you...and promising to do something, lets get with them. We put the whole community in favor of that movement there. And to be honest with you, that was fantastic and I believe the best thing we ever did!

Interview by Adam Lelyveld and Indira Stewart, March 17, 2000.

REVEREND JUÁN FRANCÍSCO

I came originally from the Dominican Republic [with my family], by way of Puerto Rico, to New York and then to Rhode Island. I lived in New York for a year and a half or so. My experience in New York went beyond

An invisible representative can only produce invisible results . . .

Juan Francisco wants to be your visible representative . . . Juan Francisco wants to produce visible results for you.

ON NOVEMBER 6, CHOOSE A WINNER!

Elect Juan Francisco

STATE REPRESENTATIVE 20TH DISTRICT

Reverend Juán Francísco election poster. *Courtesy Reverend Juán Francísco.*

what I want to refer to as "culture shock." We just had an awful experience there, in a way, because New York also has some good things happening there, but, you know, we came to the poorest of the neighborhoods, we came from a relatively quiet type of setting in our youth. You know, I was quite

young then, and what we found in New York was very disturbing. At least in that particular part of town…violence and drugs primarily…dilapidated housing and deplorable living conditions.

We moved to Providence after making the determination that we had to get out of New York. We had some very creative friends among our group that were very systematic about it and they just began to look at different states and to consider different pluses and negatives. Believe it or not, we found Rhode Island was closest to our experience in our native land, in terms of the housing, little did we know, but it was the housing primarily, the quietness, the pace of life, the beauty of the area, the vegetation, all that.

When we first arrived in Providence, it was interesting, the time that we came, which was about 1969, 1970. [We found that] people were still so controlled in the city, particularly [people of] color, so that when the police saw three or four people standing on a corner talking, they would stop by and say "disperse," and so we'd have to go home. And you couldn't stay out too late at night or the police would come and bother you, and they'd force you to go home. We were the "newcomers" as they called it, and they didn't know quite what to expect.

One thing that was for sure at that particular time was the exodus from the neighborhoods here, whites going to the suburbs. We noticed that, so that politics were, for us, at that time, very nonexistent, and it was more at the level of community organizations that evolved through the Catholic Church and independent movement that we concentrated our efforts. We felt that we needed to do something to exert our rights, to advocate and to protect the community on a number of issues that we felt were very important. [During that time], we would come into contact with the political structure here and there, and that sort of began to develop in us a certain contact, an interest. And we came to the realization that for us to ignore the political process would have been a very serious mistake at that time. So people like myself and other folks began to really try to understand how politics worked in the city and the state. But it began and soon evolved in a sincere and very genuine need to really make a difference and help.

The way I did this was that first I decided to focus on [politics] in my studies in school. I studied Latin American Studies, with a minor in political science. I felt that I needed to have an academic understanding of [community activism] and at the same time get directly involved in it. We realized then that to be able to have a voice you have to be able to vote. We realized that we were at the level of non-profit community involvement that when we came in contact with the politicians, who really wanted to make

you feel bad, they would say to you, "Yeah well you don't even vote. Why are you coming in here and pushing demands on me? You're not going to make a difference to me come the election time. This group votes." That's what they did. Pitting one group against the other, and we knew that even though it was an attempt to minimize our worth in the community, that it was a necessity to do that. So I was one of the first people who began to promote in the Hispanic community the importance of voter registration. I remember we had a lot of people who felt the same way as I did, and the politicians soon began to pay attention to us. And so a little bit of recognition and political influence [for the Hispanic community] began to evolve as a result.

I never made the mistake of describing my community as the "Dominican community," but instead I was Hispanic or Latino. I felt that the Latino community was at a real disadvantage if people felt that way. We made sure that there was a philosophical understanding of working together. That this was understood, even in writing; that this was not something that limited us. The majority at that time were Puerto Ricans and Colombians. The Colombians were concentrated in the city of Central Falls, and then the Puerto Rican community concentrated here [in Providence] and in Pawtucket.

There were a lot of issues with immigration; there were a lot of issues with police brutality, and a lot of issues with housing. You know, we knew that we had a lot of people who were living in very substandard conditions, and they were being exploited by individuals who were here and began to move out to pay their bigger mortgage in the suburbs. And they were very racist…Yeah, they were very racist and didn't care, and so we felt that we needed to have some protection and work with agencies that would promote better housing conditions not only for our community, but our larger neighborhood. At that time we were getting involved in all sorts of things.

Education was the issue that was important to me. We felt that the educational system was just not providing adequate education to our community, so we began to promote bilingual education, ESL and also tried to expose the inconsistency of the system towards minorities and particularly, in this case, of Latinos. We began to conceive the idea of providing English as a second language right in the community at that time. And we did. And in promoting education, that opens doors to the community in different ways, such as training, etc., so we had a whole department in our community organizations that dealt with that.

It was a strategic move based on the observations that I told you before where we came to realize that being a community organization was like

being a turtle without a shell, you know, without protection, if you did not have political involvement. So, at the same time we recognized that the system wanted us to be helpful, by the fact that this system was willing to provide us assistance in community and non-profit organizations savings, but with the understanding that we were not to get involved in politics. So we said okay, fine, the community organization itself can do that, but we could form an organization specifically separate and apart from this and nothing can stop that. So we had some encounters with some politicians that brought us to conclude that even the community organization, the non-profit community organization by itself, was in grave danger if we did not exercise some political muscle, and that was how the whole idea of a strategy developed—it was consistent, it was intended, it was planned. It was not something that happened by accident, you know. Our plan was to organize and develop a community organization, and at the same time, we would develop a political strategy that would serve the purpose of protecting what we have. So we began to do that and it began to work.

Interview by Indira Stewart, March 2000.

VALENTÍN RÍOS

My name is Valentín Ríos, and I moved to Rhode Island in the early 1960s. I was one of the first Colombians here. Jay Giuttari brought three men that came on March 8, 1965: it was myself, Gustavo Carreño and Horacio Gil, who was also my boss in Colombia.

I had just turned 24 years old on February 12, before I came to Rhode Island. I was not married at that time, I was single, and in fact, I met my wife later, here in Rhode Island.

I have a copy of my passport, which shows that I arrived by way of Miami. Actually, I came to Rhode Island on the 9th. We landed on March 8th in Miami at 7 o'clock [in the evening], and by the time we arrived to Rhode Island, it was the 9th. Jay met us at the airport around 2 o'clock in the morning, and we spent the night in a motel in Rhode Island. The next day, he came and picked us up and gave us some coats because it was cold. From there he took us to a restaurant to eat breakfast, and then he drove us to the company that his father owned—the name was Lyon Fabrics.

When we got there, he introduced us to the other people who worked there, and then we started working the next day. We went right to work, yes! You see, I couldn't really afford to take any time off because when I left our country, it was a dream to come here and start a new life. I knew I was ready to go right to work as soon as I arrived.

There Are No Four Seasons in Colombia

[In] Colombia where I come from is the coast, and it's usually around in the 90s that time of year, so I wasn't used to this cold weather and it was something we just didn't expect. We were grateful to Jay for thinking of that and for giving us coats the moment we arrived. And, wouldn't you know, I saw snow within a couple of weeks after we arrived! Yeah, I was very cold…it was very difficult to adapt to that change of climate compared to Colombia. Colombia has areas where it is a bit cooler, but from where I'm from in the coast, it's very hot almost every single day. And it doesn't rain a lot; there's a rainy season from October to November, and that's what we call "winter." So winter here is so different from winter there…really there are no four seasons in Colombia.

I was born in Barranquilla, Colombia. We were very poor and I didn't have the luxury of traveling around, so I never really saw much outside of Barranquilla. Really I was still young and was just starting to make my life over there. I didn't start working until I was around 20 years old, and I was just doing odd jobs and things like that. In about 1962, I got a job as a weaver in one of the local mills.

After a while, I became very unhappy and was looking for a better opportunity, and that's when I saw a notice in the newspaper in Colombia that there was a company in the United States that was interested in hiring weavers. Because I was a new weaver at the time, with two or three years experience, I wrote to that company and within a couple of days, Jay came, he stopped at my house. I remember he was driving a Jeep, and he pulled up in front of my house and came in to talk with me; I was sitting just inside, with my door open. After he introduced himself, he said, "You answered my ad in the paper, and you wrote to me so I'd like to interview you." So, he gave me a card and invited me to his business; he used to own a company in Colombia. The very next day, I went to that company, and Jay and an associate of his interviewed me, and he explained that his father owned a textile mill in Rhode Island. He also said that he wanted to send a Colombian or two to

Rhode Island because they couldn't find any workers to fill the jobs; no one wanted to work in the textile business in Rhode Island; they were moving into other kinds of jobs. And so I said I would like to go, and then he asked me if I knew anybody else whom I could recommend. I told him about Gustavo Carreño, and after I got home, I told Gustavo to write to Jay. And that's what he did.

We ended up getting hired by Jay or getting an offer, then we started all the paperwork: we got a passport, our visa and that took a long time. And then when we got everything ready, they helped us with airfare to fly to the United States. And that's where I started my story, the day we arrived in Boston on March 8, 1965.

My plan was to stay in the United States for about five years and then to go back to Colombia. But my plans changed because I met my wife and you know…and in those five years I also had planned to work and help my family back in Colombia. I left behind my father and four siblings, and one of my brothers is ill, he's an epileptic, and we weren't able to help him with medications. So when I first came here, I sent them money often to help with that. (I still do!)

After a little while, I spoke to Jay and asked him if he could bring my other brother, Gustavo Ríos, and he said, "Yeah." Then Jay drew up a contract and brought my brother to work for his dad in June of 1966. My brother, Gustavo, worked for Jay for a short while, and I worked for Jay for five years. But then in 1970, I left Lyon Fabrics because I wanted to learn to become a machinist, so I went to Cumberland Engineering, on the border of Rhode Island and Massachusetts, about a 15-minute drive north of Central Falls. Then, later on, my brother came to work for that company too. Three years later in 1978, I heard that the Boeing company was recruiting people to work for them, so I wrote to them just like I did years before in Colombia, and I got hired. It was then that I packed up and moved my family from to Rhode Island to Washington State. I worked at Boeing from 1978 to 2003—I retired when I was 62 years old to take care of my wife, who was ill.

So many people have told me that this sounds like a successful story, and I agree, because I feel I accomplished a lot and was able to retire with a good pension. I'm lucky. This never would have happened if I hadn't met Jay and he brought me here.

Picking Tomatoes

When I arrived in 1965, it was only the three [men I've mentioned] who were Spanish speaking, but we later met a *Puertorriqueño*, who spoke Spanish. Gustavo brought his wife but not until later, so really, we saw no other Latinos at that time other than that Puerto Rican man.

When my brother and I first worked for Lyon, they closed for one week in July for vacation. And my brother and I did not qualify for unemployment pay because we were so new, so the Puerto Rican man took us to a farm to pick tomatoes. I lost touch with him soon after, and I think his name was Alberto, but I'm not positive. I do remember that he was a very nice man.

I don't remember where exactly in Rhode Island we picked tomatoes, because we didn't have a car and didn't really know much about the area. This man picked us up and took us to a big field; that was his job, to pick tomatoes, and he recruited us and he took us there for just one week from Monday to Friday while we were waiting for Lyon to reopen. It was such a long time ago and for such a short time that I really don't remember many details about that.

For about seven months, we were the only Hispanics or Colombians in Rhode Island, just the three of us, until other groups of Colombians started coming. Jay brought more weavers because the Colombians were doing pretty good work for him, and none of the Americans wanted the weaving jobs because they were not interested in that trade. So I guess we were such good workers, and soon another textile mill [Cadillac Mills] also started bringing other Colombians to work for them.

What was it like in Central Falls at that time? There were many Portuguese living there; many of us became friendly with the Portuguese workers who also worked at Lyon. But we didn't really understand each other because our languages are so different. I was happy when within 6–8 months after I arrived many more Colombians began to arrive…first 10, then another five to make 15, and that's how they began to arrive.

Pedro Cano and the Spaniards

One day, one of the Colombians who arrived later in the fall of 1963—his name was Pedro Cano—he got to know a family living in Central Falls who was from Spain. They lived on Cowden Street. Their last name was Ramos, and one day, Pedro told me at work how he had met this family and they

seemed very, very nice, and he wanted to introduce me to them. So I said, "Yes, yes I'd like to meet them."

Pedro Cano was also one of the first Colombians to arrive, but not as early as I did…he came a few months later, in the fall. Around that time, beginning in the early fall of 1963, many others arrived. Fidel Alberto Villas, for example, he came first then his wife and children. Jay has told me that Fidel's kids were the first Colombian children to enroll in an elementary school in Rhode Island, in Central Falls. After the first two men I mentioned and myself arrived, Fidel came next, then after him it was Pedro Cano and the others.

So it was Pedro that told me about that Spanish family and I went to meet them. The address was 17 Cowden Street in Central Falls, right off Broad Street. Apparently, Mrs. Ramos seemed to like me and then told me, "We have three apartments here that you can rent if you need one, so you won't live alone." Pedro rented one and I took the other. It was not very clean, but I scrubbed it until it shined, and that made Mrs. Ramos very happy. They rented it out to me for about $10 a week! I lived there from 1966 until around 1969, when my daughter was born. (She was born in St. Joseph Hospital; my son was born at Memorial.)

Food • Comida

As for food, Jay had to show us some new things. In Colombia we didn't even have a refrigerator. In those days in Colombia, we would buy things like fresh meat and fresh chicken and cook it that same day; we didn't put it in a refrigerator. It was very different here, and Jay had to show us how you could buy canned goods, T.V. dinners and things like that. I worried because some of the Colombians didn't know better and sometimes would buy canned dog food [because they couldn't read the label], and Jay and I had to stop them from eating it!

But we learned quickly and we learned we had to buy and get used to the food here. We always found things like rice and meat with potatoes, but we couldn't find the beans that we were used to—*habichuelas*. We would shop at a regular store because we could not find a "Hispanic Market" anywhere. It was difficult at first trying to communicate when we bought food because we couldn't understand English, and [Rhode Islanders] didn't understand us and didn't know exactly what we wanted to eat. There was a Chinese restaurant near our house, where I could

walk, and there they made a *bistec*-like dish, just like we were used to in Colombia. I went there often after payday because it was so good and so similar to what we ate in Colombia.

When more people started coming, especially more women (wives of the workers), then it became difficult for them because they wanted to start cooking the food we were used to. Because I was single, it didn't matter to me what I cooked or ate, and I went out to eat more often. But for the women, it was a difficult adjustment.

A 1953 Cadillac, a Foldout Couch and Seattle

I bought my first car when the Ramoses offered to help me find a car. They taught me how to drive, and I bought my first car in 1966, a 1953 Pontiac. I learned then to drive for the first time in my life—I was already 25 years old. The car I bought cost just over $100, and I did that on the condition that the Ramoses' eldest son would teach me how to drive. It was a car with gears, so it was a bit more difficult, but I adjusted quickly.

When Gustavo and Horacio and I first arrived, we shared a very small apartment with a foldout couch. Because Horacio was older, we let him have the bed. We bought a television at Sears (a black and white TV), and among the three of us, we shared things that needed to be done: food shopping, cooking, etc. Then Horacio moved, found another apartment and bought a car—he had learned to drive a car in Colombia—and when his wife arrived, they found an apartment together.

Gustavo and I stayed together, then his wife arrived and I was left alone in the apartment until I met the *Españoles*, the Ramos family, who rented me the apartment. Gustavo had five children, and Jay helped him bring his family. Jay helped a great deal! He helped everyone and reunited a lot of families from Colombia. Gustavo's wife arrived first without the children. But she really missed them and became very sad, and soon after a few months, they all came and everyone was together again.

Gustavo eventually went to work at Cadillac, and he took me with him. But I soon became disillusioned and called Jay to see if my job was still available at Lyon, and he said, "Yes, of course, we have plenty of work." So I returned to work for Jay.

Then later I married a woman that I met when I was taking ESL classes at Tollman High School when I first arrived. She did not speak Spanish; she was a Rhode Island resident. We eventually moved to East Providence and

bought a house there, then we moved to Connecticut, right on the border near Putnam, Connecticut.

Once I moved to Seattle and started my new job and new life, I really didn't stay in touch with too many people in Rhode Island. The only person I never lost touch with from the early days is my brother, Gustavo. And now, I've been reunited with Jay Giuttari, who called me this year [2014], and it's been so wonderful reminiscing with him. Thank you for making that possible.

Interviewed by Marta V. Martínez, April 28, 2014.

DON PEDRO CANO SR.

I was born on August 19, 1919, so that makes me 78 years old right now [1988]. I left Medellín, Colombia, and came to Rhode Island in the winter of 1965, and it was cold when I arrived. That was something I had never experienced, because in Colombia it is always warm. I was recruited to work in a mill called Lyon Fabrics Company by a man named Jay Giuttari. He told me that his father needed skilled workers to work in the mill, and he also told me that there were a few other Colombians who had been working at Lyon since 1964. My friend, Gustavo Carreño, was one of those workers, so I already knew about the jobs in Rhode Island and I did not hesitate to tell him that I would come. It was Gustavo who had recommended me to work at Lyon because he knew that I was a good worker. I had studied at a technical school in Colombia to become a machinist, and I was good at my job. I was good at fixing looms.

At first it was hard for me to leave Colombia because I had a wife and 11 children, and they could not come with me. Lyon only needed skilled workers and they did not think I should bring my family. But they promised to help me bring my family after I arrived and worked for a while. I found a small apartment near Lyon because I walked to work every day. I worked many hours, up to 12 hours a day sometimes. They paid me about $2.20 per hour and I would send almost all the money I earned to my wife, Olga, in Colombia. I kept enough to pay rent and to buy some food, but everything else I would send to her so she could some day soon come to live with me in Central Falls.

Pedro Cano Sr. *Courtesy the* Providence Journal.

Pedro Cano Sr. at the Quinceañera of his daughter, Anna. *Courtesy Anna Cano-Morales.*

I did not know English, but at work all the Colombians spoke to each other in Spanish, so English was not important. Jay Giuttari spoke some Spanish too, so he would sometimes talk to us and ask us questions about our work, and sometimes he would ask me about my family back home in Colombia. At that time, I didn't feel that I had to learn too much English because we worked at our machines all day and didn't have time to talk to the other workers. There were many Americans and some Portuguese workers, but I still did not learn enough English to have a brief conversation with them. I only learned a few words related to the machinery, so when something was wrong with one of the machines, I would recognize the word and that way I could fix it. In those days, it was hard to get around if you did not know English. Today it is easy for the young people or for those coming here from Colombia for the first time because there are so many people who speak Spanish. There are interpreters in doctor's offices, city offices and there are several Hispanic [Colombian] markets where we can shop. Back then we didn't have any of that. It was sometimes difficult for me to go to a doctor's office or to buy food at the market. There was a market in Providence where some of the Colombians would go to buy [Latino] food. A Cuban family owned it, but I don't remember the name of the store. We would go there to buy food and to speak Spanish because we would also find other people speaking Spanish there when we arrived. There were a few Puerto Ricans at the time, and they seemed to enjoy talking to us as much as we enjoyed talking to them.

Today, it is hard to imagine that we lived like that in those days. Central Falls has changed, and now we have so many [Latino] markets, restaurants, record stores and people in the street can be heard speaking Spanish every day. There are also so many other people [from Latin America], and not just a few like when I first arrived. Life is very different for my children today, and I am proud and happy that they do not have the struggles that we did in the 1960s. My entire family finally came to live with me in Central Falls by the early 1970s, and today all of them are busy going to school, working and enjoying life with their own families. I retired from Lyon in 1984, 20 years after moving here. And today I am still very busy and enjoying what life has to offer.

Note: Don Pedro passed away on January 14, 2012, at the age of ninety-two.

Interview by Marta V. Martínez, April 11, 1998.

OLGA (ESCOBAR) NOGUÉRA

I was born in Guatemala, in Puerto Barrios. It is located at the mouth of Lake Isabal and the state by the same name. After a year I moved to a place called Zacápa, where my grandparents come from, and that's the place where I grew up. I had two children when I lived [in Guatemala]. I worked for the labor department, and one of things that I noticed when I was working there was that there was a company in Guatemala that came to establish a kind of contract business, and the only place that you can have a contract with Guatemala was through the labor department. [While I was there], this friend showed me a letter from a family in Wayland, Massachusetts, that said they needed someone to take care of a two-month-old baby. So when she decided not to take the job I asked my grandmother for her support, and she told me to go and she would take care of my kids.

So, I came [to work for] the family [in Wayland], the Sherman family. A Cuban friend said to me one day that there were programs where you could work part time, and the state would pay the difference making the same amount of money as if you were working full time while you went to school. I went and applied, I was lucky to get a job in this packing place—actually

Olga Noguéra (right) with Catherine "Kitty" Channell at a meeting of the HSSA. *Courtesy Marta V. Martínez.*

Olga Noguéra (second row, left) with the HSSA in the 1980s. *Courtesy International Institute of Rhode Island.*

they packed jewelry, they sold a lot of jewelry from Rhode Island, and it was interesting that the first place that I saw the name Rhode Island was in that packing company.

So after I came to Rhode Island, I decided to go back to school, and I received my Associates Degree in education and social services. But before that I became active in the Colombian community, in a group called *Acción Hispana* in Central Falls [what is now *Progreso Latino*], and that is how I begun my activism in Rhode Island in 1978–1979. At that time in 1978, members of the Hispanic community and *Acción* started the Hispanic Social Services Committee, in Providence (HSSC).

The reason why this group HSSC was formed was because there were many Spanish-speaking, bilingual people who work in an English-only environment. We were the only ones that deal with the non-English-speaking persons. So we would get together to support each other and to support this community. We invited people from the gas company, we invited people from different companies and asked why they didn't have anyone who spoke Spanish in their companies. They said, "Well, we don't need anybody, we don't have anyone that comes and asks for services." We said the opposite, "Well, if you don't have anybody that speaks the language, then nobody will come." And I think we did a good job, and that is why the gas company and the electric company have bilingual people working there; it all started with the HSSC.

A year later, in 1980, the Hispanic Social Services Committee became the Hispanic Social Services Association (HSSA), and under the leadership of board members such as Cynthia García-Coll and Ralph Rodríguez, we incorporated, we created by-laws, became a 501(c)(3) and hired our first Program Director. In 1988, Marta V. Martínez became the first Executive Director, and she led the organization until it became CHisPA [Center for Hispanic Policy and Advocacy] in the late 1990s.

I think that we have done so much with the Hispanic community that people who come now should be very proud of the people who opened all these doors for them. We did a lot in the early days, but there is still a lot of work to do because of discriminations and racism. But I think that we made a lot of strides, and I think that we need to encourage young people to participate in the Hispanic community.

Interview conducted by Mónica Lucéro, July 13, 2000.

ROBERTO GONZÁLEZ, ESQ.

Roberto González moved to Rhode Island from New York City in 1969 with his brother, José. After being invited here to visit, their mother decided to bring the family (including a third brother) to raise them in what she felt was a safer environment. Roberto eventually became the first Latino judge in Rhode Island—sworn into the Providence Housing Court in 2004.

My aunt on my father's side was the first one in our family that came to Rhode Island in the mid-1960s. And the way she came was through her husband, who was in the Navy; he got transferred to the Newport Naval Base. I remember that he and his entire family lived in the Newport Naval Projects, where the Navy men and their families were stationed.

During that time, we would come and visit occasionally. We noticed back then that there was a number of Hispanic, mostly Puerto Rican families living in Newport. We learned that some came through the Navy, and some through their association with the nursery owners or farmers, who would recruit Puerto Ricans and bring them to Newport sometime around the 1950s and '60s to work in Middletown and Portsmouth.

Once we moved to Rhode Island, we joined three of my aunts [my mother's sisters] who were already here, so it was nice to be reunited with all of them. One of the interesting things about one of my mother's sisters—that's my aunt Delia—is that she was very active in New York with the Pentecostal Church. So when Delia moved here, she and her husband just about brought a whole congregation with them and established a church here in Rhode Island. This was some time in the mid-'60s, so I do believe it was the first Hispanic church in Rhode Island. I don't remember there being an earlier one than that one.

Our home, on Messer Street, was in the West End of Providence, on the Cranston St. side. At that time, the neighborhood was predominantly Irish. And on the West Minister side, it was predominantly Italian. So we were kind of right in the middle of the Italian and Irish communities. And not too far, a couple of more streets over, you have Elmwood Ave. and Broad St., which were predominantly Black neighborhoods.

I remember, I'll never forget my first day in school. Wow, what an experience that was! My brother, José, and I went to Central High School; I entered as a senior and José was in 10th grade. And back during that era, there were race riots going on. There was the infamous riot at Hope High School the year before that. And there was still a lot of that percolating, if you will. So in school, I'll never forget, my first experience was going into the cafeteria and seeing that students sitting on one half of the cafeteria were White, and the other side they were Black...almost as if there was a line going down the middle.

And here is the dilemma I had: Where do I sit? And, the truth is, coming from New York I felt like I had more in common with the Black students. I just felt a comfort zone with the Black students there than with the White students, who I didn't really know much about.

Roberto González, Esq., 2012 *Photo by Marta V. Martínez.*

And I remember sitting there, and someone approached me and asked me, "Hey, who are you? Where you from? Are you Portuguese?" And I said, "Well, my name is Roberto González." He says, "Oh, Gonsalves." I said, "No, González." He says, "You mean 'Gonsalves.' That's the way we say it around here." And I later found out that there's a huge Cape Verdean community in this area, and of course the Cape Verdean and the Portuguese communities do pronounce and spell the name "González" differently.

So then the next thing I found out was that there was going to be a huge fight after school, and students were trying to find out whose side we were going to be on: mainly, were we gonna be on the Black side, or on be on the White side? And then I later find out that you have to be careful what door you even exit the school from: are you going to exit on the White side, or on the Black side? So that was my first experience in Rhode Island, it was essentially like a race riot type of scenario. A powder keg, if you will.

I was not in any way prepared...that was my first kind of awkward experience. And we definitely didn't fit in. I mean, the way we dressed, you

could tell that we were different. And everything about us was just different. But we quickly made friends.

There were probably six Latinos at Central High School back then. Luis Del Rio was already there. Luis, of course, is now a policeman. Juán Francísco, who's now a minister, was also at Central High School. And there were a couple of others who today are still quite active in Latino affairs.

One interesting thing I should say is: When I left New York, I was going to Stuyvesant High School, which is one of the top schools in New York City. There are probably three very well-known high schools for their academic rigor in New York: Stuyvesant, Bronx High School of Science and Brooklyn Tech. So I had a very solid academic background. And when I came to Central, I found out there were very few courses that I could take that were at that level.

So that was my year at Central; I don't think there was one other Hispanic graduating with me. I was the only Hispanic that graduated in 1969. So, from there I went to URI. I was accepted into the Talent Development [TD] Program. There were a number of Rhode Islanders that went into the Talent Development Program, which was in its second year. TD was almost like an affirmative action program for the university. This was the time when Martin Luther King had just been killed, and the whole Civil Rights Movement had begun to see some of its—the results of the struggle. So there was a heightened awareness, if you will, of inclusiveness into the universities and things like that.

I joined the Vista Volunteer Service, which was a program like the Peace Corps, which trained you, and once you were trained, you were placed with a community agency to work for the community. And I got lucky, and so did José, because José had almost the same trajectory that I had. We were placed to work at an agency down on Cranston Street with a gentleman by the name of Charlie Fortes. Charlie Fortes was an old, Cape Verdean, merchant marine, community organizer.

And if you get to find out something about Charlie Fortes, it's that he was probably one of the best community organizers that Rhode Island has ever seen. He was from the old Saul Alinsky school of community organizing, the "in-your-face" type: picketing, raising a closed fist that was meant to embarrass the corporations, the institutions that we felt were discriminating...and things like that. Charlie had worked with the Martin Luther King movement, and he had a wealth of experience and knowledge. So he took us under his tutelage, you could say, and trained us to work on behalf of the Hispanic community. He was very astute because he saw that

the Hispanic community was a growing community, even back then when there were few of us. And he knew that it would be important to include the Hispanic community in the whole civil rights movement. So, he got us going. And we did that for two years.

Early Community Organizing

So…my early involvement with the Hispanic community was with a group out of Central Falls called *Acción Hispana*, and we would meet in a church basement. And the format we used was quite simple: People were invited, if they had a problem, to come and to state their problem. So every week, they would have this meeting and there would be between 5–10 people sitting at the table. And these people had different contacts. Some of them may have worked in a government office. Some of them may have worked in the areas of unemployment, or social services, etc.

What happened [when some of the thriving organizations run by Hispanics closed] was what naturally happens when funders don't understand a community and attempt to dictate what they believe is best for them: things just fell apart.

And the person would come and say, for example, "Well, my child, I can't get him into the school," and the group would, right away, have a discussion, and come up with some kind of an action plan. It was all action-orientated: you identify the problem and solve it immediately.

Then there was another group meeting in Providence [in 1970], and they eventually got some funding and started the Latin American Community Center, which was located over on Harvard Street. The group hired a director and they had a physical office where people could come and get some help. And the way they worked is, that they would try to get government agencies to have a representative there at certain hours of the week. So if, for example, somebody came in and said, "Hey, look, I'm having trouble finding a job," they would say, "Well, come back on Thursday in the afternoon, the unemployment representative for the state will be here." Or if people had a problem with social services, there'd be a social service person available to help. And that was the way that organization worked.

I was stationed there to help with community organizing and things like that: getting the word out, trying to do whatever I could and whatever was needed. And then, for some reason, the funding dried up and the LACC closed.

After that came the Coalition of Hispanic Organizations, or as we called it *"Coalición."* We had representatives from Pawtucket, Central Falls area and also different groups representing different interests. For example, there were groups that just were interested in doing sports programs for the community—the soccer leagues, the baseball leagues, for example. There were groups that just wanted to do beauty pageants. There were groups that just wanted to do a parade.

Then there were individuals who wanted to get into the political end of things, which is what I was interested in: community and political issues. So under one umbrella, we managed to bring everyone together, mainly for the purposes of getting some funding. And then we got a location over on Broad Street, a storefront. That was the first office of *Coalición*, and it lasted for three or four years.

And when that organization finally closed down—I want to say that was in about 1979—it almost splintered. Actually, when I think of it, the Coalition may have ended, but the different groups started to take on lives of their own, like children growing up and developing. So, one group went to the Casa Puerto Rico building on Niagara Street in Providence and established themselves there. Another group went to work with the Dominican community. Another group started doing the parade, etc. So, in essence, *Coalición* didn't actually die, but I think what happened was that everything became what they were destined to be. I mean, what funders like the United Way wanted at the time was to put all of these groups under one umbrella, to unify them under one purpose. But, as I saw it, it was just not feasible; it doesn't work that way. And I think what happened was what naturally happens when funders don't understand a community and attempt to dictate what they believe is best for them: things just fell apart.

So that's how some of the organizations that still exist today were created. Because I remember, from that came *Progreso Latino*. And the Hispanic Social Services Committee (HSSC) went off on its own and then became HSSA, later CHisPA. And other groups were formed, like *Casa Puerto Rico*, too. Yes, so the individual people that were involved early on with the Coalition stayed involved in other efforts and endeavors.

So all that movement among Hispanics goes up to right about 1979. And back then, one of the biggest concerns was getting representation at the government level: getting people to get into important jobs, getting people on commissions, getting people elected. So that was a big, big spinoff from the Coalition. And in fact, a lot of the people that were involved with the Coalition ended up getting politically involved in one way or another.

Political action groups formed, such as the Hispanic Political Action Committee, and there was the Puerto Rican Action Committee: Jorgie Sanchez, Tito Matos, Lydia Rivera and others. I remember the group eventually went from getting people out to vote and getting involved in candidates' campaigns to actually doing more of the, "Well, we want to meet with all the candidates, and get their positions, and tell them what we need," and such. And towards its later years, that's what was happening. They were having meetings where they were bringing the candidates and having community forums. And I remember going to some of these forums where they would get a dozen cases of beer to attract people, get some food out and then they would invite the candidates to come and talk to the group. The room would be packed with Hispanics, and the candidates took notice.

Latino Groceries and Restaurants

During the 1970s and '80s, my family did all its local shopping for Hispanic groceries at Sanchez Market [on Douglas Avenue, Providence] and also Fefa's Market [Broad Street, Providence]. But these markets didn't always carry everything we wanted, so we would go to go to New York three times a week. Eventually we [my brother, José, and I] opened up a restaurant. It was called Antillas Restaurant. We served Puerto Rican/Dominican food, and we had two cooks: one was my mother, and the other one was a Dominican lady. But there's very little difference between the cuisines of either culture. Antillas was located on Broad Street, right across from Cavalry Baptist Church. The building is gone now; it was torn down.

So we began to take regular trips to New York because with the restaurant, we had to go and buy in bulk. [My brother] José was in charge of supplying us, so he would take a truck, and he would go to Hunt's Point Market in New York City. And he would buy not only for us, but he would also buy for some of the other establishments and bring it back, and deliver or resell it to them.

I believe that Antillas was probably the first true Latino restaurant in Rhode Island, because Fefa had a restaurant, but it wasn't really a stand-alone restaurant. It was inside her store, and she served food in a little corner. Ours was exclusively a restaurant.

The idea to open this restaurant came from Michael Reyes and myself. We were the principal investors. We enjoyed the restaurant business, but it was risky: the work was hard, and we were all going to school and trying to get on a professional track, so as time went on it didn't really correspond very

well with what we wanted to do. Restaurant work is extremely hard work. Michael and I both had families, and we figured that we would get family to help and work at the restaurant, but it turned out to be a lot of work, and when we got an opportunity to sell it for a profit, we did.

Interview by Marta V. Martínez, August 2007.

OSVALDO "OZZIE" CASTILLO

My name is Osvaldo Castillo, and I am one of 11 kids in my family. I came to Rhode Island in 1968. One of the reasons that I came here was because my father decided that because he had a big family, he was going to move to the United States. He was working at the time for a company called Caribe Nitrogen, which is in the Guánica side of Puerto Rico. He was a veteran from the Korean War, and when he was drafted, he did not speak English and he found that to be a very difficult thing. Because of that experience, he didn't want us to be drafted to any war. So the company that he was working for had an office here in Rhode Island, and he asked for a transfer. He came first, and [my brothers and sisters] came right after him—it was in 1967, I was 17 years old and we lived in the Southside of Providence. I went right to work in the same company where my father worked, which was in Johnston, and we made chemical formulas for colors. I never went to school here.

At the time, we found only around five or six Puerto Ricans in Rhode Island. Even though we came from different cities in Puerto Rico, we created a little neighborhood, if you want to call it that, of Puerto Ricans. This was in the Southside of Providence, around the Broad Street area. I remember then that there was only one market that had Hispanic food, it was right across from Roger Williams Park. It was called Fefa's Market, and that is where I bought most of my food.

Later, more and more Puerto Ricans started coming to Rhode Island, mostly from Connecticut or Massachusetts. They found jobs in the manufacturing industry. Many of us used to get together and go to different houses, to visit other Puerto Rican families. At the time, we listened to Beatles music; it was really cool at the time. And later, we listened to disco music. We also used to go to Central Falls to a club by the name of Batista Club; it was

Osvaldo Castillo organized the Puerto Rican community in Rhode Island in the 1970s and '80s. *Courtesy Marta V. Martínez.*

a Cape Verdean club—it had the only music that was close to Latin music at the time. Quite a few of us used to go there all the time. It was cool.

Sometimes we would have some problems, racial tensions in South Providence. This was just before the racial riots, but it was never that violent. It

was just that some of the people who lived there at the time didn't identify with people who did not speak the language, English. It was hard because many people could not communicate in English. You see, in Puerto Rico, we don't see colors—it's mostly the middle-class people that hang around together, and they are all very similar. Black, White and Brown Puerto Ricans, we get along well down there. So when we came to Rhode Island, especially in the Southside of Providence, we found ourselves in the middle of some tension.

There were also other things that were very different here, when I first came to Rhode Island. The weather, for one, was a big change. And the people… down in Puerto Rico, I remember we used to help out our neighbors. So if your neighbors need coffee, you open the door, give them coffee and everybody stands around on the streets; you could walk home with your friends. When I came to Rhode Island, I felt that people didn't trust each other; they weren't friendly until they got to know you better. Here I began to feel more inferior and felt I had to become somebody who I really wasn't.

Today, the community has changed a lot because it is larger. I see more bilingual people working in government offices, and back in the early days, there was none of that. I also speak better English, but I still feel bad for the people who are just arriving to this country because they have to go through what I went through. But, now because the community is larger, they really don't have to worry so much because there are better services for them.

In the 1970s, in 1974, I became a police officer for the City of Providence. I was the first Hispanic police officer in Rhode Island. At the time, I was working for a company called American Cards when one of the workers there said to me, "What are you doing here? You should be doing something else." He showed me an ad in the newspaper, in the city of Providence they were looking for police officers. So I applied, went for a few interviews and a few tests, and I became a police officer on June 28, 1974. And then in 1976, I remember the country of Guatemala had an earthquake, and I noticed that there were some Guatemalans in Rhode Island, but they did not have any kind of assistance from anyone, from the news media, from the government; no one was really helping them. So, because we spoke the same language, that's when I really got involved with the Hispanic community, became motivated and I started helping them out. And Mayor Cianci, who was mayor at the time, assigned me to work directly with the Guatemalan community, helping to bring the news to them, take up collections for them and things like that.

Later on, in the 1980s, I became disabled and left the police force, so I became more involved in the Puerto Rican and Latino communities. I was the founder of the Puerto Rican parade in 1984 and also that same year

was one of the founders of *Casa Puerto Rico*, which was a multi-service center for the community. At that time, there was a great need for the community for all kinds of services. *Casa Puerto Rico* was located right in the heart of Providence—it was between Elmwood Avenue and Broad Street. It fulfilled a great need for the community. The elderly needed to be fed, kids needed to have a place where to go; there was also a "cultural" need. Older people that were here, they needed to [stay in touch with] their culture, and that's why I had it in my mind to open up a multi-service center for the community.

That same year, in 1984, we [Puerto Ricans] renamed a street from "Bishop Street" in South Providence to "Borinquen Street" because some people had a problem pronouncing that word. In Spanish, that is a bad name, the word *bicho*, and so we renamed it *Borinquen*, which is the ancient name of the island before the Spanish arrived and renamed it Puerto Rico. I don't know if you are aware of that. But the mayor at that time helped us, and Councilman Tom O'Connor.

I think that the Puerto Ricans have worked hard to make our neighborhood a better place since the old days, but the Dominicans also deserve a lot of recognition. There are quite a few of them in the city of Providence; the census, the 1990 census, shows that in the city of Providence, the majority [of Hispanics] are Dominicans. Not by much, though. And they're doing quite well and opening quite a few small businesses. They're working very hard, and they deserve any credit that they get, with the mayor or whoever is giving them the credit. Working together is progress for everyone, not just Hispanics, but everybody benefits. If you were to have seen the neighborhood years ago, in the 1970s, how bad Broad Street and the Elmwood section were. But today the Puerto Ricans and Dominicans are working together to make the place better, and that benefits everybody.

Interview by Tyler Katz, Angel Quiñones and Laura Lee, May 1998.

JOSÉ M. GONZÁLEZ, EdD

José González has been a subject of the Latino Oral History Project of Rhode Island on several occasions. In this interview, he talks about education: bilingual education, in Rhode Island and on a national level; the educational policies effecting all children in the Providence Public School and especially what it means to be "Hispanic" in the school

system; and his own education, including his experiences in schools in New York, where he grew up, and his goal of getting into Harvard University in Cambridge, Massachusetts. A leader in the Rhode Island Hispanic community since the 1970s, Dr. González shares with us his visions on education for Latinos and has some important words for both non-Hispanic and Hispanic youth and for all people of color about how to succeed and what it means to work hard to reach your dream.

I was born in New York City, and I was raised in Brooklyn. Spanish was my first language. I was 15 years old when I moved to Rhode Island; I was starting the 10th grade. That was in 1968. Growing up in Brooklyn in public housing, there was a lot of crime and violence. My whole family had been in New York since the late 1940s, and they were starting to move out of New York. Part of my family went to Miami, I had family going to New Jersey, California and some family left for Chicago. My aunt was married to a guy in the Navy, and he was stationed at the Brooklyn Navy Yard. When they closed, they relocated him here to Rhode Island, here to Newport. So [my aunt] was living here maybe three years, and she told the rest of the family to come. And we did. Those that didn't go to New Jersey and the other places ended up coming here to Rhode Island.

In New York, there weren't any bilingual programs, and I spoke Spanish the first four and a half, five years of my life. So when I started kindergarten, I didn't understand anything. As a matter of fact, from kindergarten to grade three, I don't remember having any conversations. I see pictures [in my mind] of what I was doing, but I don't remember speaking to people or understanding people, their conversations. So the first three years of my schooling were just acquiring language, trying to communicate. Now, I remember some of grade three and some of grade four, and from there on I was learning English and speaking English. But at home it was always in Spanish. The way I learned English was a forced assimilation of language.

I went to junior high school right in Brooklyn. Then, I went for one year to Brooklyn Tech High School, which is one of the five examination schools in New York. You have to take an exam to get in; just as here in Providence, we have Classical High School, which is a public high school, but you can't get in unless you pass an entrance exam. There were few students of color there. I was in one of these pilot minority programs. This was right after desegregation when they were trying to integrate the selective schools, which were basically all white. I don't remember taking the test or anything, but I got accepted into Brooklyn Tech, which was a pre-engineering high school.

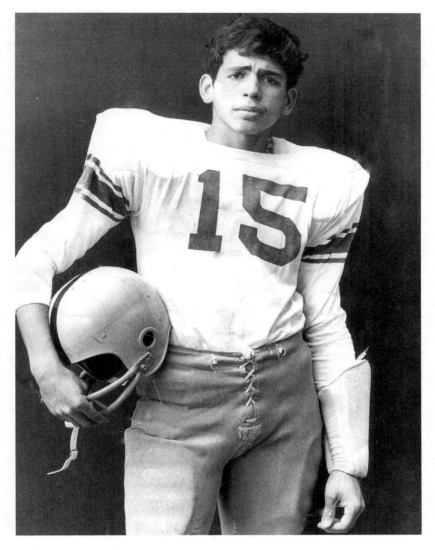

José M. González poses for a photo for the Central High School, Providence yearbook, 1960s. *Courtesy José González.*

When we moved to Providence and went to high school here, we really didn't find an ethnic mix. There were six Latinos who graduated from Central High School the year I graduated. Six Latinos! People then didn't know what Puerto Ricans were. They thought I was Cape Verdean. They thought I was Portuguese. They thought I was everything else, but they had

never heard, they didn't even know where Puerto Rico was. A lot of people couldn't even tell you on a map where it was. They didn't know that we spoke Spanish. It was a very new experience. Central High School is so different now, from when I graduated—right now [2002] it is 60 percent Latino. And there were six of us then that weren't down in the basement, in the ESL class. So, the numbers have really turned around.

For my first year in college, I went to the University of Rhode Island. I went through the Special Program for Talent Development [TD], which took in inner-city minority kids who would not normally have been accepted by the university. If I had applied on my own, there was no way I would've gotten in. But through this program, an educational opportunity program, they took me in. The TD program did offer help. We had study groups, we had tutors. They even gave you financial incentives, like book awards and monthly stipends. The whole idea was that the university environment was not created for people who are not white middle-class students. In the '60s and '70s, they started to address the need to bring in more people, but not necessarily to create a more diverse and receptive environment for the diverse populations. There was a handful of us [in this program], maybe twenty-five.

So my first year at URI, I was totally overwhelmed. I didn't do well. I got kicked out of the university because I just didn't have the skills and abilities to survive a university experience. I was coming from a public school in Providence that was, again, large, urban, underfunded and drastically underprepared its students. I was just devastated.

After that first year, I transferred to Rhode Island College. There was no difference between the Latino community at RIC and URI. At both schools the Latino presence was insignificant; it wasn't anything. We formed the first Latin American Student Organization (LASO) with a handful of students. The first LASO at RIC was in 1972. And again there were maybe eight students that were Latinos. And that was it. And you know when we mentioned LASO [to others in the school], people would think there were forty, fifty members. We would actually threaten to strike or have a sit-in because they wouldn't give us resources like the other organizations. We wouldn't get stipends [for our activities] and had no student activities support. They just saw us as rebels, so we played the role. We were rebellious.

What was the reason for my success at RIC compared to URI? Well, you know I think it was persistence. You realize that what other people have you need to have, and that they are no better at it than you are; that you are fully capable of doing equal, if not better than the work they can do. It is

just quickly trying to catch up. I had no study skills, but I learned. When I entered college I must have been at an eighth-grade reading level. I hated reading, and I realized that had to learn to love reading. I really hated the library. I thought it was a ghost town, and I never wanted to go there. But I knew that it was a source of knowledge. So what I started to do was sort of uncover, to develop a greater awareness of who I was and what I needed to address, face my deficiencies. So I went to get help from other people, I went to the writing center. I never handed in a term paper unless someone had read it through, and people worked with me.

After I received my undergraduate degree at RIC, I went on to get a master's in bilingual bicultural education. It was a two-year program at RIC, and when I graduated, I had a bachelor's degree in social work and a master's in education. I wanted to help people. I've always enjoyed helping people. Because I was bilingual, my family took me everywhere, to the hospitals, to the welfare office, to help someone get new glasses. I was always translating for someone in my family. I don't even know how well I translated, but I was always helping people. Neighbors would call my mother and would say, "Hey could I borrow your son to go and get something here...or there..." So, as a result, I thought social work was a good profession.

My main goal then, was to give back to the Latino community by going into social work. But I had a moral dilemma. In social work you sometimes provide too much support and don't educate people into becoming independent. And you have this realization that the best way you can help the Latino community is by educating them. You know it's like the story about being a fisherman: If you give somebody a fish, they can eat it today. But if you teach them how to fish, they will be able to eat for the rest of their lives. So I thought, people don't need handouts, what they need is a hand up; to get out of poverty.

Here I will use the example of my two brothers and myself. With the help of a single mom, we grew up on welfare and lived in public housing. My older brother [Roberto] is the first Hispanic judge in the state of Rhode Island. My younger brother is a mechanical engineer with General Motors. And I went to Harvard and got a doctorate in education. Hey, that's almost unheard of in this society. But it demonstrates that it can be done, that there is a great possibility. And what do you have to latch on to? Education. All three of us had this awakening. It was either work in the factories, or in the fast-food restaurant, or deal drugs and steal cars, or get your act together and utilize the resources that are out there. And education is one of these free resources.

After I got my master's, I went to New York, and after that I went to URI and I worked in their admissions office. In 1990, I started my doctorates degree while at URI and then I went to Harvard's Graduate School of Education. I really did it because I wanted to challenge myself, but at the same time to prove to the rest of the society that we [Latinos] can be PhDs, EdDs, MDs—all of the Ds we want. I finished my dissertation in 1997, and then I started to look for a more significant job. That's how I became the director of Equity and Access at the [Providence] school department.

In closing, I would like to say one thing: Hispanics are not going anywhere until we can develop enough of a power base in politics to influence decision-makers who have no right to make decisions for us. We have to educate the people that it is important to show up, it is important that you let people know you will be going out to vote in November. That's the bigger picture of the kind of situations that are still so challenging.

So we serve, we are social workers, we are teachers, we're educators; we are creating the new generations of leaders. But today's leaders are challenged by the same things again and again, with the same challenges we had when I first moved to Rhode Island. I couldn't get people to come out and vote years ago, and it still seems that today's leaders are having the same trouble getting out the vote. Even though we are more organized, we have voter registration, you can't get a license if you aren't registered—you know, things like that. There's been much improvement, yet there is much more that needs to be done.

TESSIE SALABERT

Tessie Salabert was born in Cuba. She was sent to the United States on April 10, 1961, as a result of Operación Pedro Pan *(Operation Peter Pan). Tessie was eleven years old when she left with her two siblings: a fourteen-year-old sister and an eight-year-old brother. In her thirty-five-year career at the Rhode Island Department of Labor and Training, Tessie helped immigrants and Spanish-speakers in the community to secure employment. Tessie further served the community in her twenty years as a board member for* Progreso Latino.

I was born in the city of Havana, Cuba, and I came to the U.S. when I was 11 years old. Up to that point, I had a very nice childhood, actually. We had a very nice life socially in terms of schooling. I was a swimmer, a competitive

swimmer. [My family and I] weren't considered the rich, but we weren't considered the poor either. We were, more or less, the middle class, and [I thought] we had a nice life.

My father was a medical doctor, and as such, he had to work very hard. What I mainly remember [about] him then is that he was always working. And my mother was what you might call a "housewife"; she was usually at home. We just had a nice life

So how did I end up in the United States? Well, let me begin with a little bit of history. Fulgencio Batista y Zaldívar was the elected president of Cuba from 1940 to 1944, and dictator from 1952 to 1959, before being overthrown as a result of the Cuban Revolution. Most of the Cuban people, including my family, were not happy with the situation because we felt he was not good for the country. I was only a kid, so I don't remember the details of how that came about, but I do remember when Batista left the country because everybody was happy that we had freedom, that we got rid of this dictator.

After Batista fled, Fidel Castro came in, and everyone thought that things were going to be different. But he turned out to be the opposite of what the Cuban people were led to believe: he declared himself a communist, and when that happened, that's when he started changing things in the country. He wanted the children to go and cut sugar cane out in the countryside. I wasn't of age because there was an age limit, but my sister [who was thirteen years old] would have been involved. And I know my parents didn't want her to go anywhere like that. [Castro's people] would just take the children out of the family home, and we didn't know exactly where they would go. And there were a lot of horror stories in terms of things that happened to the kids.

So when all that started, all I remember is that people started leaving the country. My friends were leaving; everybody was leaving.

And there was always some kind of protest going on here and there. I loved going to school because there was always something going on. I remember things like fliers falling from the sky, and to me that was exciting; it was like an adventure.

So my parents said, "We're leaving. We're leaving the country." First they started saying, ok, my sister has to get out, because she's not going to cut sugar cane. And then everybody knew—I know my father knew—about an invasion that was coming [April 1961], and that was the Bay of Pigs. And everybody thought, "That's it, Cuba is going to be saved, and we're going to get rid of Castro." Obviously, that didn't happen.

Tessie Salabert, 2013. *Photo by Mary V. Quintas.*

So suddenly, all I remember is that we [just my siblings and I] knew we were getting prepared for "something." Because we had to get permission, we had to go here and there: we had to get our picture taken, we had to get vaccinated. So we were getting ready [for a trip somewhere], but we didn't know when or where we were going. Or at least, my parents weren't telling us. I had in my mind that we would leave now [April] and would be back by September.

At that time, we didn't know what was happening or where we were going. I was a little bit scared, but I also felt it was an adventure. We were just kids, and I found myself walking around in awe, almost in a trance.

We left on April 10, 1961. I remember going to the airport that day, and they took us into what was referred to as "the fishbowl" because it was a building made of glass. Our parents couldn't come; nobody's parents were allowed. It was all just children, all waiting for the plane to leave. When we boarded the plan, there were lots of kids already there, inside the plane.

So then, I noticed that we were supposed to go to Jamaica because that's what was written on our papers, but we were first making a stop in

Miami. But when we arrived in Miami, everybody got off and nobody went to Jamaica. When we went through Customs, they told us that we were students, but also referred to us as "refugees." In Miami, I was still in awe, looking at everything, and everything was different, and everybody was speaking English.

Fortunately for us, we did speak English; we could understand because we had good schooling, I guess. We were taught English since early on in Cuba, so we could understand everything. And we said, "Oh, it's not bad." Now, my brother didn't know any English before we left Cuba. He learned his English later that summer, while playing with kids after we left Miami.

It was then that maybe I realized we weren't going back to Havana as quickly as we were told, but I don't remember ever feeling that we weren't going to get together with my parents again.

Miami

So when we arrived in Miami, we were taken to this place where the Ursuline Order of Nuns were taking care of the girls. And there was another couple, a Cuban couple, that would take care of the boys. The location was in the middle of nowhere. It was in Kendall [south of Miami]. I'm sure today it's not really "in the middle of nowhere," but at the time, it seemed like a long ride from Miami, and when we arrived we were surrounded by a lot of trees; it felt like we were entering the woods.

Kendall was like a stopover—the Catholic Church ran it, and that's why the nuns were there. The plan was that this would be temporary and that they would be sending you somewhere else because obviously you couldn't stay there. As for my two siblings and me, I know they had to find a place where the three of us could go, where they would take both boys and girls.

My recollection is that Kendall was a building that had been given to the Catholic Church. But I don't know what that building had been used for at the time; it was all one floor. When you first walked, there was what I think was the reception area. A little bit further down was the dining hall. And then, towards your right, there was a wing, which was the girls' dormitory. And then on the left, there was a boys' dormitory.

It was a compound because there were also other buildings in the area, where we had classrooms. We would have school in the mornings. There was a playground and also a playroom-type area where we would

go and just hang out. My guess is that it had probably been some kind of a training school.

As the days went by, we saw some of the kids leaving, and then they would write to everyone saying things like, "[Our new home] is wonderful!" Kids were sent all over the United States, to places like Washington; Oregon; New Mexico; Washington D.C.; New York; Georgia; Tennessee.

Iowa

So about one week before the Bay of Pigs incident, my sister, brother and myself ended up in Dubuque, Iowa. Once the Bay of Pigs happened, it became obvious that we were not going back to Cuba.

It was in May of 1961 when we traveled to Iowa. For us it was an ordeal, because from Miami, we had to go to Chicago. And the plane from Chicago to Dubuque was…I still remember, it was the Ozark Airlines, and it was a small plane, one of those planes that had the tail down!

And when we walked into this small plane, we had to go and sit in a seat. And we said to each other—it was just the three of us then going to Iowa, "Oh, my God. Where are we going? This is such a small plane!" And we were a bit nervous about that.

And then I don't know what the problem was with the weather, but we couldn't land in Dubuque. So we landed in Waterloo, Iowa. And from Waterloo we traveled by car—like a limousine, they sent for us—from Waterloo to Dubuque.

While in Iowa, I ended up going to a foster home with a large family— they had nine children, and I was the 10th. But they treated me well; they were very, very nice. I was probably the one that made out the best. My sister was never placed anywhere, and my brother went to two different families, but I remember that they weren't very nice. My brother was very young; he was only eight, and they had to move him from his foster homes twice. It was at that point that my mother, who had left Cuba soon after we did and was waiting in Miami to be reunited with us, was finally allowed to come for us in Iowa.

I stayed with a family until my mother came, and then she got an apartment. And we moved in with her, and we stayed there until my father was able to join us.

Miriam, Eduardo and Tessie Salabert pose for a picture after they arrive in Iowa, 1962. *Courtesy Miriam Gorriaran.*

Family Reunited

In 1962, a little more than a year after we had left Cuba, we got the call: my father had escaped. He came by boat. After he arrived in Miami, he was detained there for a week before he was released.

You have to understand, this was after the Cuban Missile Crisis, and my father's name had been connected with the Department of Health in Havana, which was a government agency, so they had to make sure he was cleared before they let him stay in the U.S. After he was cleared and they let him go, my father called us in Iowa to let us know that he was here in the United States.

My father didn't come up to Iowa right away; he stayed in Miami. He got a place, and he studied because he knew what he had to do—he knew that he had to study for his exams so he could practice medicine in the United States. My father was very intelligent, and in a span of two months, he took the exams, passed and then he came to be with us in Iowa. My birthday is in November, so I still remember that he came right around my birthday. And then we moved in January.

So during that short time in Iowa, neither my mother nor my father liked it there—it was very, very cold. And the town was such a small town at the time. We came from a big city, and it just wasn't their thing, that's for sure. But there wasn't any question about staying there or not; my parents just didn't enjoy it a lot.

Even though my father had been practicing medicine in Cuba for many years, he had to start all over again with an internship. At that point, there was a possible job, an internship in Rhode Island. He took the time to visit Rhode Island, to see about the job and then to look for an apartment where we could live once we moved; he found one in Pawtucket.

I think he knew someone in Rhode Island—another friend, another doctor who was living here, who helped him find everything we needed. And he said, "Well, you know, it's not a bad place." And he went to Pawtucket Memorial Hospital to check about the job. And whatever they offered him, you know, it was better than anything else he had been offered.

So my father left in January of 1963. We were supposed to leave with him, but we all came down with the chicken pox—imagine that! So we couldn't leave until all of us were ready to travel, and of course, my mother stayed with us and my father left once again.

As for my siblings and I, I do remember that we really didn't want to leave Iowa because, at that point, we had already made friends. We were enjoying

our life there, and we were in a nice high school. I was already a freshman in high school, and my sister was supposed to graduate that year, and she didn't want to come because she wanted to graduate with her class. But we had to come. The family had to be together. After all we had gone through, we knew we had to be together.

When I think of all those things today, I don't know how my parents did that. How could they and other parents have sent their children away like that? But I know they did what they had to do, under the circumstances.

Rhode Island

So, Rhode Island was the best place for a family of five. You know, in terms of how we were going to survive. Medical interns don't get paid well at all. And my parents had to find a permanent home to live and schools for my siblings and me.

The rest of us finally arrived in Rhode Island in late spring, and I liked it a lot. Before I arrived, I didn't want to leave friends that I had in Iowa and for several months after we came to Rhode Island, I was still communicating with friends, writing letters back and forth. But as time went on, that started dwindling down. I met new people here, and soon I lost track of friends in Iowa. My new life was here. We had to think of our new life, and my sister, who was ready to graduate in about two or three months, enrolled and graduated from St. Xavier's High School. I also finished my 9th grade in Pawtucket, and then I started sophomore year at Pilgrim High School the following fall, when we moved to Warwick. I stayed at Pilgrim and I graduated in 1966.

Interview by Mary Quintas, May 2013.

MIRIAM (SALABERT) GORRIARAN

My sister and brother and I came to the United States in 1961 as part of an international and historical event called Operation Peter Pan, or in Spanish *Operación Pedro Pan*. Our lives and that of our parents changed dramatically at that time. I now believe it was all for the good, but certainly not without

many ups and downs that we and a host of other Cuban children experienced at that time.

This all happened in 1960–1961—almost eight months after Fidel Castro came into power in Cuba. We left in April of 1961, and by that time, Castro had done a lot. He had already declared himself a socialist. And then a little bit later, he declared himself a communist. First, he broke off relations with the U.S., then he changed the currency and he closed schools.

Most of the religious people who worked in Catholic schools were gone by 1961. Even if the schools stayed open, the religious people were gone. Why? Well, because Castro at one point talked about taking over the Catholic schools, and so many nuns and priests began to leave Cuba. He wanted to close all private schools, get rid of private education so that the government would be the one educating the children. Everyone knew that Castro wanted to indoctrinate the children, and that's just what he did.

Castro forced many of the religious education teachers to leave on their own accord because once the schools were closed, the nuns and priests did not have a place to live. The nuns lived in the convents that were part of the schools, so once they closed the schools they had no choice but to leave Cuba. Because they belonged to a larger order, they were told, "Ok, get out, come on, let's go!" And this created a large exodus of religious people that left Cuba. Eventually, Castro also closed the churches, and that forced many priests to leave as well.

One day in April of 1961, my mother told me, "Ok, well, I'm going to be calling you around lunchtime, and I will then let you know whether or not you're going back to school the following day." So we were all standing around waiting next to the phone when she called me, and she said, "You're not going back tomorrow, but do not say anything. That's it. You're not going back." Once my parents decided we were leaving Cuba, we left two days later, and we had only one day to get everything together. Just one day.

But the plan all along was that this would be temporary, that we would be back in Cuba within a month or so. As a result, I came to this country with only one piece of luggage.

Why did we expect to come back in 30 days? Because we knew about the Bay of Pigs…everybody [in Cuba] knew about the impending invasion of the Bay of Pigs [on April 17, 1961], it was no secret! And we, along with everyone else, were convinced that it would be successful and that we could return to Cuba when it was all over.

What my parents and many other parents did then was to make a very hard decision, and I don't think I could do that today if I had to make a

Miriam Gorriaran, 2014. *Photo by Marta V. Martínez.*

choice like they did. But they were forced to do it because but there was a threat by Castro. There were strong rumors that the state was going to take children from their parents and send them to the countryside of Cuba to cut sugar cane. Later on, we heard that this actually did happen.

In Cuba at the time, there were families that are raising their children as best as they could, giving them all that they could. And it was hard for parents to imagine that they were going to allow their children to be sent to work in the fields! Everybody had to go, boys and girls. Let me tell you, there were a lot of rumors about was a lot going on in those fields! So my parents said *NO* to that. My parents, like all other parents, felt that the government was going to take over the children completely, and parents were not going to have any say in their upbringing.

We also heard rumors that boys, like my brother, who was only 8 years old at the time, were going to be put in the army. So, all those things forced my parents to make the decision that brought us here.

We really didn't know where we were going, but we were very excited! Because, you know, we were so young and this was an adventure. And we

felt we would be back in a month anyway. And so, so many of my friends had already left Cuba, and I felt it was all going to be fun. We also knew that we were all going together, my brother and sister and I. My mother told us, "Stay together. Stay together. You always have to stay together!" And we have always stayed together, to this day.

When we arrived in Miami, we were taken to a place called Kendall, which is in the southern part of Miami. There, it was fun in a way because I saw many familiar faces. I actually saw one of the nuns that I had in Cuba; she was there taking care of the children. When I saw her, I was very happy to see her! Her name was Mother Imelda. (We used to call them Mothers. We didn't call them Sisters back then.) When Mother Imelda saw us, she came up to us and hugged us and stayed with us. She was very interested in learning about what was going on in Cuba since she had fled herself.

I went to a reunion last year, and Mother Imelda was there. It was a reunion for our school, the school we would have graduated from in Havana. You know, you spend what seems like your whole life in a school, and suddenly it ended so abruptly for me. If I would have stayed in Havana, I would have graduated from high school in 1963. And so all those kids, now adults, we got together for our 50th anniversary reunion. Some of the nuns who are still alive were also there. Mother Imelda attended, but she was very old and fragile. Today, she lives in Puebla [Mexico], and she's quite elderly. Unfortunately, she didn't remember me; she just doesn't remember much anymore.

One of the most interesting things I found out about Mother Imelda many years later was that she was originally from Taunton, Massachusetts! Can you imagine? That was so amazing! I never knew until that day at our reunion!

Eventually, we learned that all the kids that had been there before us were allowed to stay there for 30 days, for one month, before they were sent to different parts of the country. Soon, some of the children that we became friendly with were sent to Oregon. And everybody who went to Oregon loved it, so we wanted to go too. But the problem was that the three of us couldn't go to Oregon; they would have to split us up. And that was one of the things that my parents told us, that we must always stick together.

After our 30 days were up, we were sent to Dubuque, Iowa. We went by plane. And, and we couldn't land in Dubuque because of bad weather, so we landed in Waterloo. And I always say that was our Waterloo. Like Napoleon Bonaparte: another battle.

When we finally arrived in Dubuque, someone picked us up and took us to this place similar to the St. Aloysius Home [in Rhode Island.] There, the

boys were sent to one side of the building, and girls went to the other side. And my brother, oh, my poor brother—he would sit on the stairs on one side, just waiting for us! He didn't know English, and he was only eight years old. And he would sit on the stairs, just waiting to see if he could see us. It was very sad. They wouldn't allow the boys and the girls to cross to the other side, even if we had a relative on the other side.

We got to Miami a week before the invasion of Pigs—the Bay of Pigs—so we were all glued to the radio; we listened to everything that was going on in Cuba. It was then that we started thinking, "Hmm, what's going to happen now?" And pretty soon, we realized that we were probably not be going back home after all.

High School and Proms

While we were in this home in Dubuque, there was a nun, a Franciscan nun, who was assigned to take care of us. She had escaped from China, so in a way, she knew a little bit about what it was like to be a refugee. When I think back, she really did the best she could.

Then I enrolled in high school. I knew I would have to go to a Catholic school, and I was told that I could choose from two different schools. At first, I decided to go to an all-girls school because I was used to going to a girls' school. But then I changed my mind, and I chose the co-ed school, and that turned out to be a good choice.

Soon after I enrolled, it was prom season. It was my first prom! And not only did I not have any money to spend on a prom, but I didn't have a dress to wear! We found out that people outside of the group home would donate clothing, and sometimes they would donate wedding gowns or evening dresses. And the Franciscan nun took one of those dresses and transformed it! I still remember it today: it was a black satin dress, with little spots of red. And the nun fixed it so that I could wear it to one of the proms.

And then for the summer prom, she took a wedding gown, and she fixed it for me too. She took it apart so that I could wear it. And you know, when I think back to that, I am still in awe! That was truly amazing what she did. In Dubuque, there were other Cuban girls there, which was nice because, you know, we had a lot in common…I still have a picture of some of them. One of my good friends who was there is Lissette Alvarez; she's a well-known singer and dancer. She's married to Willy Chirino. Willy Chirino is also a "Peter Pan Kid."

The story of how my father came here is very fascinating. He had to escape from Cuba—they wouldn't let him leave. He tried three times to leave Cuba, and the third time, he finally was able to make it. But he was in the water for 17 hours. 17 hours! He came in a motorboat. That's the only way he could come.

What my father did is, he became friendly with a fisherman, and he offered to buy a little boat where they could both go fishing. So he would regularly go fishing with this guy, so it wasn't so peculiar whenever he went out. Finally, when he decided it was time to escape, they went out one day, but there was a storm and they had to go back to shore. They tried again with no success, and then the third time they finally did it. This time, however, they took several people with them. There were five people that left in that boat that time; all of them hid down under the belly of the boat. There was a woman with a baby, and they had to sedate the baby so that the he wouldn't cry.

Here's what happened: the day they planned to leave and were ready to go out "fishing," suddenly the guards who looked after the waters on the coast of Cuba didn't allow them to go out. But the guy who owned the boat convinced the guard; he told him, "Oh, you know, I haven't been out, I haven't been out fishing for a long time. I have to get out." And blah, blah, blah.

So, they were allowed to go out, and they were almost caught! After they went out on the water, the guards noticed the boat kept moving and that no one was fishing, and they went after them. When they were close to international waters, they almost caught up to the fishing boat! The Cuban boat was literally almost on top of them. My father always said that they all believed it was a miracle when suddenly this American boat—the Coast Guard—appeared out of nowhere. All of a sudden, the Coast Guard boat was just there!

And when that happened, the boat that was chasing them from Cuba suddenly turned around and went back. They were saved! Oh, they were saved!

So then my father was put in seclusion for almost a week after he arrived in Miami—by the United States government. He had to be interrogated because of his different positions in the Cuban government. And you know, they knew everything about him. And they also knew where we were. Everything. They knew everything.

As for the other people in the boat, he lost track of them all together. Once they got to the U.S. and they pulled him aside, they were separated right away. They probably sent them somewhere else for questioning.

Meanwhile, in Iowa, we didn't know what had happened. We knew that he had done something, and we didn't know what had happened because he

couldn't get in touch with us. But finally, he called us in Dubuque. When he first contacted us, we were so thrilled!

And then, my parents talked things over, and they decided that my father had to do something because there was no question now that we were staying here in the U.S.

What they decided was that my father would take an exam so that he could practice medicine in the U.S. All foreign doctors, the first thing that they have to do to practice medicine in the U.S. is to take what they call the "ECFMG exam." So my father said, "I have to do it." Because his English was so-so, he was worried about that. He then spent three intensive months training, learning English and studying so that he could take the exam. And then he took it, and he passed.

He was still in Florida when he was doing this. He said it was better that he was by himself so he wouldn't be distracted, and so he could just concentrate on this before he came to meet us.

And something that happened during that time that to me was a wonderful thing is that I became closer to my father. He wrote to me a lot while we were in Miami and also when we moved to Dubuque. I had never really been that close to my father. I was close to my mother when we were younger, but not with my father because he was always so busy working. So while I was in Dubuque, we would write to each other all the time, and we got very close in those letters. And we were very happy. I do think this happened because of the time we spent apart. Yes, I'm sure of that. I'm sure it would have never happened in Cuba. And I became like his right hand in many ways after we moved to Rhode Island, up until the time he and my mother left to go back to Miami in 1974.

The Cuban Club

Soon after we arrived in Rhode Island, we began to connect with the other Cubans through the International Institute of Rhode Island. We would go to the International Institute parties, when they hosted all kinds of ethnic events with food, music and dances. The director at that time was William O'Dowd.

A few years later, in 1967, my parents, along with Felipe Eiras and Raúl Sánchez, founded the Cuban Club in Rhode Island. Before my parents founded the Cuban Club in 1967, there was a Cuban Committee that was part of the International Institute. The new Cuban Club had a membership, and there were dues, and out of that they created a fund to

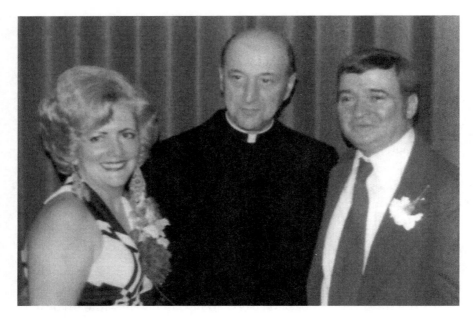

Left to right: Virginia Salabert; Father John Rubba, OP; and Eduardo Salabert. *Courtesy Miriam Gorriaran.*

help the newcomers that were still leaving Cuba for Rhode Island. And then we would be the ones taking them here, there, buying things for them, giving them food or giving them clothing and things like that.

Yeah, in those days, there were no government-run programs—nothing like that. It was out of the people's good hearts that we all helped each other in the 1960s. My parents and members of the Cuban Club made sure everyone was taken care of.

Interview by Marta V. Martínez and Mary Quintas, April 2014.

HOW YOU CAN PARTICIPATE IN THE LATINO ORAL HISTORY PROJECT OF RHODE ISLAND

In recent years, many people have found oral history to be a valuable tool for exploring the past. Oral histories (also known as oral testimony and oral memoirs) convey a dramatic, firsthand view of history with a storytelling approach and a sense of personal experience. Conducting interviews with family and community members illuminates the way historic developments affect everyday life.

Oral testimony can provide powerful insight into the experiences of Hispanics who first moved to Rhode Island and how they might compare to what is happening around the country in a broader sense. The 1960s, for example, was a time of local political upheaval and other social movements covered by the national news that played crucial roles in shaping this era, such as the Vietnam War, the civil rights, the hippie movement and the Chicano movement in the Southwest. We can learn whether newly arrived Hispanics were even aware of these more global movements or issues; rather, were they too busy dealing with their own interpersonal experiences of assimilation into American society—learning English, finding work, taking driving tests, enrolling their children in local schools and other simple tasks of figuring out how to use the American currency? These and other such stories of everyday survival are what we all take for granted. Oral testimony is an excellent tool for studying how the lives of these new arrivals may or may not have been affected. Oral memoirs can help us to move beyond easy slogans to see the complexity and the human drama of the human experience.

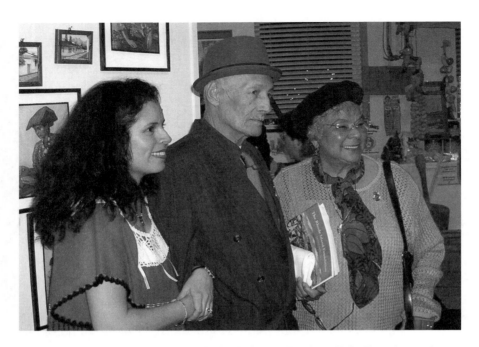

Left to right: Anna Cano-Morales, Pedro Cano Sr. and Josefina "Fefa" Rosario reunite at an exhibition of Latino history held at the Rhode Island Foundation, 2004. *Photo by Marta V. Martínez.*

Yet all oral history projects present special challenges. Sometimes we assume that first-person testimony represents the absolute truth, "the way things really were." It is more helpful to approach oral history as a form of memory—an individual's way of interpreting and narrating their experience during a particular event or period. Seen this way, oral memoirs can help us understand the crucial role of perspective and interpretation in history. This is particularly valuable in studying a controversial period, such as the example of life in the 1960s, as mentioned earlier. Oral memoirs that present contrasting views of this period can help us explore the conflicts that divided the nation during these years, as well as how issues raised then continue to shape our social and political discourse today. In addition, oral history can bring forth the history of ethnic groups that our children will never find in their history books at school. It can serve as a way to inspire young Latinos and to provide rising Latino leaders with a foundation and insight into the kinds of battles their forbears led that brought them the things that they take for granted today.

How You Can Participate in the Latino Oral History Project of Rhode Island

For more information, or to participate in the Latino Oral History Project of Rhode Island, write to us at PO Box 25118, Providence, RI, 02905, or send an e-mail to info@nuestrasraicesri.org. You can also visit our website at www.nuestrasraicesri.org.

BIBLIOGRAPHY

Buckman, Robert T. *Latin America 2001*. Harpers Ferry, WV: Stryker-Post Publications, 2001.

Carpenter, John, and Patrick T. Conley. "Rhode Island Latin Americans." *Providence Visitor*, August 2, 1974.

————. "Rhode Island Latin Americans." *Providence Visitor*, August 23, 1974.

Chapman, Francisco. *"Las Migraciones Internacionales en la República Dominicana (Santo Domingo)."* In *Migración Cultural Caribeña: Ensayos*. Edited by Baez Evertz. Providence, RI: Ediciones CCE, 1994.

Cockcroft, James D. *Latinos in the Making of the United States*. New York: Moffa Press Inc., 1995.

Ferguson, James. "Latinos in New York: Communities in Transition." *Latinos in New York: Communities in Transition*. Edited by Gabriel Haslip-Viera and Sherrie L. Baver. South Bend, IN: University of Notre Dame Press, 1996.

Hoye, Paul F. "Six Cuban Girl Refugees, 9 to 13." *Providence Journal*, May 13, 1962.

Johnson, Albert R. "Only 15 Mexicans in RI, but Consul Is Kept Busy." *Providence Journal-Bulletin*, February 1, 1938.

Meltzer, Milton. *The Hispanic Americans*. New York: Thomas Y. Crowell Publisher, 1982.

Popkin, George. "R.I. Opening Hearts to Cuban Refugees." *Providence Journal-Bulletin*, March 8, 1962.

Rodríguez, Juan Carlos. *The Bay of Pigs and the CIA: Cuban Secret Files on the 1961 Invasion.* North Melbourne, VIC: Ocean Press, 1999.

Sánchez-Korrol, Virginia. *From Colonia to Community: The History of Puerto Ricans in New York City, 1917–1948*. Wesport, CT: Greenwood Press, 1983.

Scotti, Kiki. "Cuban Club Gives Assistance to Refugees." *Providence Journal*, June 19, 1967.

Taylor, Maureen. *Rhode Island Passenger Lists: Port of Providence, 1798–1808; 1820–1872, Port of Bristol & Warren, 1820–1871*. Submitted to County of Clearfield, Pennsylvania, 1995.

U.S. Bureau of Census. *The Foreign Born Population by Race, Hispanic Origin, and Citizenship for the United States, 1990, 2001*. http://www.census.gov/population/foreign/data.

———. "Summary File 1 100% Data." U.S. Census, 2000. Available at American Fact Finder, http://factfinder.census.gov.

U.S. Commission on Civil Rights. *Puerto Ricans in the Continental US: An Uncertain Future*. Washington, D.C.: Government Printing Office, 1976.

ORAL HISTORY PROJECTS/INTERVIEWS

Alper, Robin, Emily Drury and Josh Torpey. "The Colombian Community in Central Falls, Rhode Island." Oral history interviews, 1998.

Brooks, Victoria, Indira Goris, Thuy Anh Bguyen Le and Kelsey Merrow. "Dominicans and Providence: A Symbiotic Relationship." Oral history interviews, 1998.

Cano, Pedro. Personal interview, 1998.

Casiano, Julio. Personal interview, 1996.

Castillo, Mayra, Jennifer Guitart and Kelly Shimoda. "Rhode Island's Guatemalans." Oral history interviews, 1998.

Giuttari, Jay. Personal interview, 1997 and 2014.

González, José M. Personal interview, 1997.

González, Roberto, Esq. Personal interview, 2007.

Gorriaran, Miriam. Personal interview, 2014.

Katz, Tyler, Laura Lee, Kate Levine and Angel Quiñonez. "Puerto Ricans in Rhode Island: A Study of the Community." Oral history interviews, 1998.

Martínez, Marta V. Nuestras Raíces: Latino Oral History Project of Rhode Island. Personal interviews and research from the Latino Oral History Project of Rhode Island Archives, 1991–present. www.nuestrasraiceri.org.

Mendóza, Victor. Personal interview, 1998.

Noguéra, Olga. Personal interview, 2000.

Quintas, Mary V. "The 1950s and 1960s: Cuban Migration to the U.S." Oral history interviews, 2013.

Ríos, Valentín. Personal interview, 2014.

Rosario, Josefina. Personal interview, 1991.

Salabert, Tessie. Personal interview, 2013.

Toledo Morales, Astrid. Personal interview, 1997 and 2004.

INDEX

A

Acción Hispana 60, 61, 63, 64, 96, 101
Alemán, José 60, 78
Alianza Hispana 77
Alinsky, Saul 100
Allenberry Health Center 57
Alvarez, Lissette 123
American Cards 106
AmeriCorps VISTA 63, 100
Antillas Restaurant 104
Antioquia, Colombia 41
Aponte, Luis 57
Aquidneck Island, Rhode Island 45
Arbenz Guzmán, Jacóbo 44

B

Baez, Margarita 66
Baltimore and Ohio Railroad
 Company 19, 48
Barranquilla, Colombia 41, 42, 87
Barrington College 73
Barrington, Rhode Island 52, 54
Batista Club 104
Batista, Fulgencio 22, 33, 37, 104, 113
Bay of Pigs Invasion 113, 116, 120,
 123

Blackstone Valley, Rhode Island 41, 42
Boeing 88
Borinquen Street 107
Boston, Massachusetts 17, 18, 45, 50,
 88
bracero program 21, 50
Bristol, Rhode Island 22, 31, 34, 35
Burchell, Edgar L. 18, 20, 49, 50. *See*
 Mexican consul of Rhode Island

C

Cadillac Mills 22, 42, 89, 91
California 30, 52
Calzada, Roberto 52
Canada 20, 44
Cano, Olga 92
Cano, Pedro 90, 95
Caribe Nitrogen 104
Carreño, Gustavo 41, 86, 88, 91, 92
Carrullo Restaurant 71
Casa Puerto Rico 102, 107
Casiano, Julio 31
Castillo, Osvaldo "Ozzie" 107
Castro, Fidel 22, 23, 34, 36, 37, 38, 39,
 113, 120, 121
Catholic Charities Bureau of Rhode
 Island 34, 36

Catholic Church 19, 44, 46, 47, 59, 60, 84, 123
Catholic Diocesan Bureau of Social Services 34
Catholic Diocese
 of Miami, Florida 22
 of Providence, Rhode Island 19, 36, 59
Catholic Welfare Bureau 34
Cavalry Baptist Church 103
census data. *See* population data
Center for Hispanic Policy and Advocacy (CHisPA) 57, 62, 97, 102
Central Council 34
Central Falls, Rhode Island 22, 25, 39, 41, 42, 43, 44, 47, 54, 63, 64, 85, 88, 89, 90, 92, 94, 96, 101, 102, 104
Central High School 33, 98, 100, 109, 110
Central Intelligence Agency 34
Chirino, Willy 123
Cianci, Vincent "Buddy" 64, 106
civil rights movement 45, 100, 101, 127
Classical High School 108
Club Juvenil 60, 64
Coalición Hispana. See Coalition of Hispanic Organizations
Coalition of Hispanic Organizations 60, 61, 62, 63, 64, 66, 80, 102
Colombia
 Antioquia 41
 Barranquilla 41
 Medellín 41
Colombians 39
 businesses 43
 community organizers 64
 employment in Rhode Island 22, 41, 42, 89, 94
 immigration/migration to Rhode Island 22, 43, 88, 89, 94
 immigration to the United States 88
 migration from Rhode Island 42
 population data 11, 25, 39
Colombo-American Association 43
community organizations 58, 59, 63, 84, 85, 86
Acción Hispana 60, 61, 63, 64, 96, 101
Alianza Hispana 77
Casa Puerto Rico 102, 107
Center for Hispanic Policy and Advocacy (CHisPA) 57, 97, 102
Club Juvenil 60, 64
Coalition of Hispanic Organizations 60, 62, 63, 64, 66, 80, 102
Colombo-American Association 43
Cuban Advisory Committee 37
Cuban Club of Rhode Island 22, 23, 36, 37, 38, 58, 59, 126
El Club Panamericano 19
Guatemalan 47
Hispanic Cultural Arts Committee 78
Hispanic Political Action Committee of Rhode Island 81, 82
Hispanic Social Services Association 62, 97, 102
Hispanic Social Services Committee 66, 96, 97, 102
International Institute of Rhode Island 18, 23, 37, 38, 125
Latin American Community Center 59, 60, 101
Latin American Student Organization 110
Orientación Hispana 60, 61, 64, 77
Progreso Latino 54, 64, 96, 102, 112
Providence Community Action Program 63
Proyecto Persona 60
Connecticut 20, 30, 71, 72, 73, 74, 92, 104
Coventry, Rhode Island 54
Cranston, Rhode Island 28, 34, 98, 100
Cuba-Borrinquen 17
Cuban Advisory Committee 37, 38

Cuban Club of Rhode Island 22, 23, 36, 37, 38, 58, 59, 126
Cuban Independence Day 38
Cuban Missile Crisis 35, 118
Cuban Revolution 113
Cubans
 employment in Rhode Island 22, 37, 118
 freedom fighters (libertadores) 17
 Freedom Flights 35, 36
 immigration/migration to Rhode Island 17, 22, 34, 36, 37, 126
 immigration to the United States 22, 23, 33, 35, 38, 118, 125
 migration from Rhode Island 23, 38, 39
 population data 36, 38
Cumberland Engineering 88
Cumberland, Rhode Island 88

D

De la Concepción, Blanca Rosa Maria 35
Del Río, Luis 100
Del Río, Minerva 68
Department of Health, Rhode Island 66
Department of Labor and Training, Rhode Island 112
DiPrete, Edward 82
Dominicans 26
 community activism 66
 employment in Rhode Island 28, 76
 immigration/migration to Rhode Island 27, 28, 37, 67
 immigration to the United States 27, 67, 71
 population data 11, 25, 27, 107
Doña Fefa. See Rosario, Josefina
Dubuque, Iowa 116, 118

E

East Greenwich, Rhode Island 20, 21, 50, 51

East Hartford, Connecticut 51
education 43, 57, 60, 78, 85, 96, 101, 112
Eiras, Felipe 37, 125
El Club Panamericano 19
employment
 agricultural 19, 20, 21, 30, 45, 48, 50, 51, 89
 architectural 37
 business 36
 coffee processing 41
 domestic 45, 95
 food service 31
 healthcare 22, 118, 125
 jewelry 76
 manufacturing 30, 31, 104
 railroad 19, 21, 48, 50, 51
 textiles 22, 28, 31, 41, 42, 44, 52, 54, 88, 94
English language acquisition 19, 43, 52, 54, 59, 60, 91, 108
Escobar, Olga 60

F

Fall River, Massachusetts 50
Family Reunification Act 27
Fefa's Market. See Rosario, Josefina
Fernández, Blanca 36
Fernández, Luis 36
Fortes, Charlie 101
Francísco, Juán 59, 60, 63, 78, 81, 82, 86, 100
Freedom Flights 35, 36
Frontier Lace. See Frontier Manufacturing
Frontier Manufacturing 52

G

García-Coll, Cynthia 97
García, Gilberto 52, 54
Garrahy, J. Joseph 66
Gil, Horacio 41, 86, 91
Gimogine, Constantinopal "Connie" 71

Gimogine, Mary 71
Giuttari, Jay 41, 42, 86, 87, 88, 89, 90, 91, 92, 94
González, José 60, 63, 78, 97, 98, 100, 103, 112
González, Roberto 60, 64, 78, 104, 111
Gorriaran, Miriam. *See* Salabert, Miriam
Green, Alma 63
Griffin, Lloyd 64, 66
Guatamalan Consulate Office 47
Guatemalans
 civil war 44
 community organizations 47
 earthquake of 1976 106
 employment in Rhode Island 45, 51
 employment in the United States 95
 immigration/migration to Rhode Island 45, 47
 immigration to the United States 45
 Mayans 44
 population data 11, 25
Guerra, Zoila 60
Guzmán, Antonio 74

H

Harvard University 101, 108, 111, 112
Havana, Cuba 112, 115, 118, 122
Hernández, Carlos 35
Hispanic Cultural Arts Committee 78
Hispanic Political Action Committee of Rhode Island 81, 82, 103
Hispanic Social Services Association 62, 97, 102
Hispanic Social Services Committee 66, 96, 97, 102
Hope High School 98
Hopkins Hill, Coventry, Rhode Island 54
Human Services, Rhode Island Department of 66
Hunt's Point Market 103

I

Immigration and Naturalization Act 27
Immigration and Naturalization Service 23
 Rhode Island Office 39
immigration/migration to Rhode Island
 Colombian 22, 43, 88, 89, 94
 Cuban 17, 22, 34, 36, 37, 126
 Dominican 28, 37, 67
 Guatemalan 45, 47
 Latino 15, 17, 25, 55
 Mexican 17, 20, 48, 50, 52
 Puerto Rican 32, 37, 72, 73, 104
immigration/migration to the United States
 Colombian 88
 Cuban 22, 23, 33, 35, 38, 118, 125
 Dominican 27, 67, 71
 Guatemalan 45
 Latino 50
 Mexican 19
 Puerto Rican 20, 30
Incera, Dr. Alfredo 37, 39
Indiantown, Florida 44
International Institute of Rhode Island 18, 23, 37, 38, 60, 125

J

Jewish community of Rhode Island 36
Jiménez, Manuel 60, 61, 64, 78
Johnson and Wales University 71
Johnson's Hummocks Restaurant 72
Johnston, Rhode Island 104
Juanica, Puerto Rico 104

K

Kappy's Liquor Store 72
Kendall, Florida 122
King, Dr. Martin Luther, Jr. 100
Korean War 104

L

Lake Izabal, Guatemala 95
Latin America Apostolate of Rhode
 Island 59
Latin American Community Center
 59, 60, 101
Latin American Festival of Music 78
Latin American Student Organization
 110
Les Shaw's Restaurant 71, 72
Lexington School 78
Licht, Richard 66
Lincoln, Rhode Island 35
Liz, Arturo 59
López, Juán 61
Lynch Liquor Store 73
Lyon Fabrics Company 22, 41, 42, 86,
 88, 89, 91, 92, 94

M

Mariel Boatlift 23, 38
Mariel Cuban Adjustment Program 38
Martí, José 17
Martínez, Marta V. 57, 76, 92, 94, 97,
 104, 126
Martínez, Patricia 63
Massachusetts 39, 88, 104, 122
Matánzas, Cuba 17
Matias, María 63
Matos, Tito 103
Mayans 44, 47
McGovern, Reverend Edward J. 34
Medellín, Colombia 41, 42, 92
Mendóza, Victor 60, 62, 66, 82
Messier, Mercedes 59
Metacomet Country Club 73
Mexican Consulate of Rhode Island
 17, 20, 49, 50
Mexican Revolution 51
Mexicans 19, 48
 consul of Rhode Island 17, 20, 49, 50
 employment in Rhode Island 20, 21,
 51, 52, 54

employment in the United States 19,
 20, 21, 48, 50, 51
immigration/migration to Rhode
 Island 17, 20, 48, 50, 52
immigration to the United States 19
Mexican-American military service in
 World War I and World War II 20
population data 17, 48
Miami, Florida 22, 34, 35, 36, 86, 108,
 116, 118, 122, 123, 124, 125
Middletown, Rhode Island 45, 51, 98
military service
 of Mexican-Americans in World War
 I and World War II 20
 of Puerto Ricans in the Korean War
 104
 of Puerto Ricans in World War I and
 World War II 20
Miriam Hospital, Providence, Rhode
 Island 36
Moreno, Dr. Blas 36

N

Naucalpan, Mexico 52
New England 18, 20, 21, 28, 44, 45,
 50, 51
New Haven, Connecticut 19, 21, 50,
 51, 71, 73
New Haven Railroad 19, 21, 50
New Jersey 39
Newport, Rhode Island 31, 98, 108
New York City 27, 28, 31, 32, 33, 37,
 39, 42, 44, 45, 67, 68, 69, 71,
 73, 74, 82, 83, 84, 97, 98, 100,
 103, 108, 112
Nicolas Romero, México 52
Noguéra, Olga 66, 97
North American Free Trade Agreement
 51, 52, 54
North Kingstown, Rhode Island 51, 54

O

O'Connor, Tom 107
O'Dowd, Raymond E. 37

O'Dowd, William 125
Olneyville 19, 30, 47
Operación Pedro Pan. See Operation Peter
 Pan
Operation Peter Pan 22, 112, 116
Orientación Hispana 60, 61, 64, 77

P

Paquette, Laurence O. 34
Pawtucket Memorial Hospital 22, 36,
 118
Pawtucket, Rhode Island 22, 36, 41,
 44, 52, 85, 102, 118, 119
Peña, Rosario 60, 82
Pennsylvania 19, 48
Pentecostal Church 98
Perkins Lace 54
Pilgrim High School 119
police brutality 62, 80, 85
political activity 30, 44, 48, 80, 82, 86,
 103, 112
Pontiac Mills 22, 42
population data
 Colombian 25, 39
 Cuban 36, 38
 Dominican 25, 27, 107
 Guatemalan 25
 Latino 11, 25
 Mexican 17, 48
 Puerto Rican 25
Portsmouth, Rhode Island 45, 51, 98
Progreso Latino 54, 64, 96, 102, 112
Providence Community Action
 Program 63
Providence Housing Court 97
Providence Public Library 60
Providence, Rhode Island 17, 18, 19,
 20, 22, 27, 28, 30, 32, 33, 34, 35,
 36, 41, 44, 45, 46, 47, 48, 49, 50,
 51, 52, 55, 57, 58, 59, 60, 61, 63,
 64, 66, 71, 72, 73, 74, 76, 78, 80,
 84, 85, 91, 94, 96, 97, 98, 101,
 102, 103, 104, 105, 106, 107,
 108, 109, 110, 112

Providence School Board 61, 64, 66
Proyecto Persona 60
Puerto Barrios, Guatemala 95
Puerto Rican Action Committee 103
Puerto Rican Day Parade 106
Puerto Ricans 30, 33
 employment in Rhode Island 30, 76,
 104
 employment in the United States 21,
 30, 31, 50
 migration to Rhode Island 32, 37,
 72, 73, 104
 migration to the United States 20,
 30
 military service in World War I and
 World War II 20
 population data 11, 25
Putnam, Connecticut 92

Q

Quidnesset Country Club 72

R

race riots 98, 99, 105
racism 97, 106
Ramos family 90, 91
Reyes, Michael 104
Rhode Island College 110, 111
Rhode Island Foundation 57
Rhode Island Lace Works 52
Ríos, Gustavo 88, 92
Ríos, Valentín 41, 42, 92
Rivera, Gladys 37
Rivera, Lydia 103
Rodríguez, Cecilia. *See El Club*
 Panamericano
Rodríguez, Dr. Pablo 66
Rodríguez, Ralph 97
Roger Williams Park 47, 74, 104
Rosario, Josefina 11, 28, 37, 46, 55, 57,
 58, 59, 76, 103, 104
Rosario, Tony 11, 28, 55, 67
Rubba, John 75, 126

S

Salabert, Dr. Eduardo 36, 37, 38, 55, 58, 113, 114, 116, 122, 126
Salabert, Miriam 58, 112, 113
Salabert, Tessie 38, 58, 120
Salabert, Virginia 37, 55, 58, 113, 114, 116, 122
Sánchez, Jorgie 103
Sánchez, Juanita 55, 57, 59, 76
Sánchez, Raúl 125
Sancti Spiritus, Cuba 35
Santo Domingo, Dominican Republic 71, 73, 74
Seekonk Lace 52
Seekonk, Massachusetts 52
Slater, Samuel 41
Smithfield, Rhode Island 35
social activism 82, 86, 97, 103, 107
social services 11, 18, 19, 33, 43, 47, 48, 50, 55, 57, 59, 60, 62, 63, 66, 96, 97, 101, 102, 107, 112
South County, Rhode Island 31, 51
Springfield, Massachusetts 51
St. Aloysius Home 35, 122
St. Elizabeth's School, Bristol, Rhode Island 35
St. John Church, Providence, Rhode Island 34
St. Joseph Hospital, Providence, Rhode Island 36, 72, 90
St. Michael's Church, Providence Rhode Island 60
St. Paul's Church, Cranston, Rhode Island 34
St. Peter's Church, Warwick, Rhode Island 34
St. Teresa Church, Providence, Rhode Island 34, 47
St. Vincent de Paul Society 34, 36
St. Xavier's High School 119

T

Tetreault, Reverend Raymond 59
Tollman High School 91

Torres, Ismael 37
Torrigan, Dr. Emerson 72, 73, 74
Trinity Church, Providence, Rhode Island 60
Trujillo, Rafael Leónides 26, 55, 67

U

United Fruit Company 44
United Way 60, 62, 102
University of Rhode Island 78, 100, 110, 112
U.S. Coast Guard 124
U.S. State Department 36

V

Valdivia, María 35
Valdivia, Modesta "Cookie" 35
Vietnam War 127
Villas, Fidel Alberto 90

W

Walsh, Father Bryan O. 34
Walton, Charles 66
Warren, Rhode Island 52
Warwick, Rhode Island 34, 71, 72, 119
Wayland, Massachusetts 95
weather 31, 38, 39, 52, 87, 92, 106
Woonsocket, Rhode Island 44, 47
World War I 20
World War II 20, 50

Y

Yankee Inn 71

Z

Zacápa, Guatemala 95

ABOUT THE AUTHOR

Marta V. Martínez is of Mexican heritage and was raised in El Paso, Texas. She is fluent in Spanish and American Sign Language. She is a graduate of Providence College. She has a minor in broadcast journalism and a master's degree in print journalism.

Marta was the director of publications at the Rhode Island Historical Society. She also served as the executive director of the Hispanic Social Service Association of Rhode Island (which later became the Center for Hispanic Policy and Advocacy, or CHisPA) and as the director of communications at *Progreso Latino* in Central Falls, Rhode Island. Marta is co-founder of the Governor's Advisory Commission on Hispanic Affairs and served as chair for more than ten years.

Marta founded the Hispanic Heritage Committee of Rhode Island in 1988 and served as the chair until 2013, at which time she was hired as executive director of the organization (now called Rhode Island Latino Arts). She is the founder of the Latino Oral History Project of Rhode Island and is a member of the National Oral History Association, the National Storytellers Network and the American Folklife Society.

She was coordinator/developer of Coming to Rhode Island—Dominican Gallery, an exhibition based on the oral history project of Dominicans in Rhode Island at the Providence Children's Museum in Providence, Rhode Island. She was also coordinator/co-curator of an exhibition on the Latino history of Rhode Island in 2004, which was based on the Latino Oral History Project of Rhode Island, featured at the Rhode Island Foundation Gallery in Providence, Rhode Island.